The Campus History Series

OGLETHORPE
UNIVERSITY

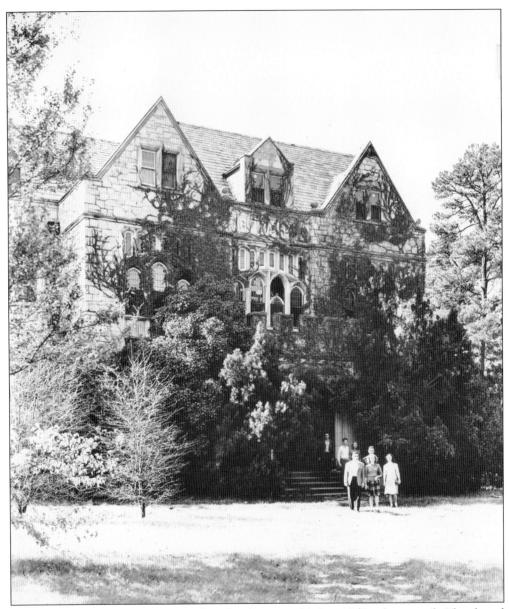

The entrance into the Oglethorpe Chapel is shown in this late-1940s photograph. The chapel was located in what would later be named Lupton Auditorium. During the first few years after the university's refounding in Atlanta, chapel attendance was mandatory and was held every morning at 8:45. The services were conducted by members of the faculty. (Courtesy of the Oglethorpe Archives.)

ON THE COVER: Taken in the 1930s, this image of Hermance Stadium, located on Peachtree Road, offers a view of one of the famous "faces" of Oglethorpe University. The stadium is much the same today as it was at its completion in 1929. Though Hermance Stadium was originally built as a football venue and field, in more recent years, it has been converted into a baseball field, named Anderson Field in honor of coach Frank B. Anderson. (Courtesy of the Oglethorpe Archives.)

Published by Arcadia Publishing
Charleston SC, Chicago IL, Portsmouth NH, San Francisco CA

Printed in the United States of America

Library of Congress Catalog Card Number: 2007921792

For all general information contact Arcadia Publishing at:
Telephone 843-853-2070
Fax 843-853-0044
E-mail sales@arcadiapublishing.com
For customer service and orders:
Toll-Free 1-888-313-2665

Visit us on the Internet at www.arcadiapublishing.com

To Dr. William Shropshire, Peter Rooney, and Barb Henry, who made this project possible and who inspire us with their passion and love for Oglethorpe University.

CONTENTS

Acknowledgments

We would like to thank everyone we have worked with during the process of writing and publishing this book. A huge thank-you goes to Dr. William Shropshire, who helped get this project off the ground. This project would also not have been possible without the support of Peter Rooney, vice president for development and alumni relations; Barb Henry, director of alumni relations; Kelly Robinson, executive director of marketing and public relations; Pam Tubesing, administrative assistant to the provost; Mark DeLong, director of publications; and Dr. Lawrence Schall, president of the university.

We would especially like to thank our committee of Oglethorpe friends and alumni who were incredibly helpful with editing the manuscript and who were instrumental in choosing the cover image: Fred Agel, Dr. Malcolm Amerson, Betty Axelberg, Edmund and Martha Bator, Bob Boggus, Gordon Bynum, Derril Gay, Elmer George, Dr. Paul Hudson, Mary Louise MacNeil, Jeanette Bentley Moon, Dr. Manning Mason Pattillo, Jeanne Schmidt, O. K. Sheffield, Dr. David Thomas, and Medora Wallace. We truly appreciate the time you spent on this project, and we were inspired and delighted by your stories about and love for Oglethorpe.

There were several people who paved the way for this book through their research and writing. We wish to specifically acknowledge Dr. David N. Thomas, Dr. Paul Hudson, and Allen P. Tankersley for their work in preserving and documenting Oglethorpe University's history. We would also like to thank Edmund Bator, who recently donated many images to the archives and who provided information about their context and significance.

We very much appreciate the hard work, dependability, and positive attitudes of our two wonderful student scanners, Kira McCabe and Martha Nodar, who will achieve much in life with their outstanding qualities. Thank you to Dr. Jeffrey Collins, who allowed us to use his scanner on several occasions. This project was also greatly helped by Joanne Yendle, who helped put the archives in order during her time at Oglethorpe.

Lastly, we would like to thank all of the alumni and friends of the university who have donated their wonderful collections of images and memorabilia to the Oglethorpe Archives, which is located within the Philip Weltner Library. Unless otherwise noted, all of the images in this book are courtesy of the archives. We are happy to be able to showcase some of its visual treasures in this book.

INTRODUCTION

The charter establishing Oglethorpe University in the small, central Georgia town of Midway was issued on December 21, 1835, one day before the 139th anniversary of the birth of Georgia's founder, James Edward Oglethorpe. By January 1, 1838, about 25 students were enrolled for classes on the campus that consisted of the president's home, a wooden chapel, and several two-room dormitories. Carlisle Pollock Beman, a native of New York, became the first president of the institution in 1836. The 21 founders were prominent Georgia Presbyterians whose churches' influence would remain a driving force behind the continuation of Oglethorpe University for the next several decades.

The founding of Oglethorpe was part of the antebellum development called the "College Movement" in which about 1,000 institutions of higher learning were established. The role of the Presbyterian Church in this movement was significant in the southeastern states. The second president of Oglethorpe University, Samuel Kennedy Talmage, was a graduate of Princeton who had come to the South as a missionary. His participation in the intellectual moment of the time continued the strong ties with the Presbyterian Church.

The Presbyterian founders of Oglethorpe faced numerous challenges in forming and influencing their young scholars. The leaders constantly struggled with retaining the moral character of their students, who were easily influenced by the evils of the capital city of Milledgeville, located nearby. The quality and influence of the faculty endured, however. During the 32 years Oglethorpe existed in Midway, Georgia, approximately 1,000 students were enrolled and privy to an ongoing number of celebrated faculty members and presidents. Scientists Joseph LeConte and James Woodrow (uncle of Pres. Woodrow Wilson) held professorships in the 1850s. Carlisle Pollock Beman, Nathaniel Macon Crawford, Charles Wallace Howard, and Samuel Talmage are but a few of the names of those early faculty members and administrators who dedicated their love of education to the university.

On May 30, 1862, Oglethorpe closed because of the Civil War, reopened briefly in 1866, and closed once again in 1869. This was only a temporary state of affairs. Oglethorpe would not only open again, but it would prove once more it had an indomitable spirit. The movement to relocate Oglethorpe University in the new capital city of Atlanta began in earnest.

In 1870, the trustees purchased the John Neal house on Washington Street in downtown Atlanta, securing a new location for the university. With a prime location and solid enrollment, the university still did not thrive. Postwar-related financial problems caused the school to close in 1872 at the request of the Synod. Presbyterians were as active in the Reconstruction period in promoting higher education as they had been in the antebellum period, and the dream of a Presbyterian institution of higher learning did not end.

During the 1890s, another push to create such an institution began with plans to consolidate and move two existing schools to the growing city of Atlanta. Columbia Theological Seminary in Columbia, South Carolina, and Southwestern Presbyterian University in Clarksville, Tennessee, were to be relocated. Plans fell through when the Tennessee school's removal was halted by their state Supreme Court. The future did not look promising as these efforts collapsed. Yet out of this movement emerged an individual who would take the idea and see it through. The spirit of endurance would flourish once again for Oglethorpe University.

Thornwell Jacobs, the man with the vision that led to the reestablishing of Oglethorpe University in Atlanta, Georgia, appeared on the scene about 1909. Possessing a gift of rhetoric

and persuasion, Jacobs was able to amass enough interest and funding to start the Oglethorpe campus. On September 17, 1912, the earliest 100 contributors to the Oglethorpe project held the first annual meeting at the Piedmont Hotel. Edgar Watkins, a prominent Atlanta attorney, helped organize a board of directors. Watkins would remain a staunch supporter of the institution for the next 30 years.

By the second annual meeting of January 1914, investors in the Silver Lake Park Company had donated 137 acres of prime land on Peachtree Road for the university. The firm of Morgan, Dillon, and Downing was hired to design the first building, and contractor W. H. George was hired to construct it. The opening, delayed one year because of World War I and a sluggish economy, finally took place on January 15, 1915, when the cornerstone was laid on the new Atlanta campus.

During the many decades leading up to the 21st century, the school would undergo a number of cyclical experiences related to fluctuating finances, curriculum changes, and reorganization of leadership roles. It would survive economic slumps during two world wars, embrace and promote new plans for learning, acquire and promote a vital sports program, and create and sustain a rigorous building plan. Each president contributed to the campus through his own area of expertise. Two goals remained firm despite the variety of leadership styles: high academic standards and excellent faculty.

Pres. Philip Weltner (1944–1953), noted attorney and educator, revolutionized academics at Oglethorpe by initiating the "Oglethorpe Idea," which involved innovative methods in a Core Curriculum providing students a common learning experience. Dr. Weltner encouraged students to "make a life and make a living," and his Core Curriculum idea has remained an enduring and integral part of Oglethorpe education.

Weltner was followed by Pres. Donald Charles Agnew (1958–1964). During his presidency, the college tripled its enrollment and night classes were introduced. The following president, Paul Kenneth Vonk (1967–1975), was an expert fund-raiser and clever financial manager. Construction of several buildings began during his tenure. The endowment was increased tenfold during his presidency.

Manning Mason Pattillo Jr. (1975–1988) came to Oglethorpe with the desire to make it a selective and academically rigorous college of arts and sciences that would attract talented, intelligent students. During his tenure, he built an outstanding faculty, student body, and academic curriculum.

Donald Sheldon Stanton's presidency (1988–1999) saw a tremendous advancement in size, and square footage of the campus buildings doubled in the course of his presidency. Several major building projects were completed under his administration, including the renovation of Lowry Hall into the Weltner Library and the building of the Conant Performing Arts Center. The Schmidt Recreation Center, physical plant, and Greek housing were also added during Dr. Stanton's tenure.

Larry Denton Large (1999–2005) added new degree programs to the university curriculum and completed several beautification projects, including the complete restoration of the Lupton Auditorium and renovations to the Dorough Field House. Dr. Large also oversaw the complete overhaul of the award-winning J. Mack Robinson Hall.

Current president Dr. Larry Schall has brought a new sense of community to the university, a renewal and enforcement of the high academic standards, and a service learning-based program, with such innovations as the Center for Civic Engagement, all designed to give students an experience outside the classroom applicable to their course of study.

This image-based history is not a definitive one. It would take volumes to accurately tell that story. This is merely a highlight in pictures of a timeline of events. The history of Oglethorpe University is fascinating and continues to be so. It is the authors' hope that you find it enjoyable as well.

—Dr. David N. Thomas

One

ADMINISTRATORS, FACULTY, AND CAMPUS LEADERS

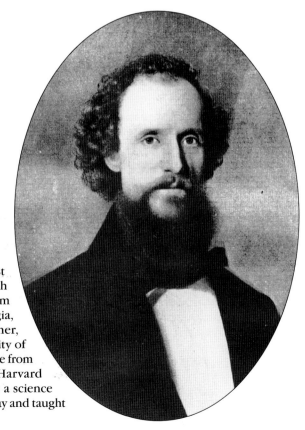

Joseph LeConte was one of the most outstanding scientists of the 19th century. His family relocated from New Jersey to Liberty County, Georgia, in 1810, and Joseph and his brother, John, were educated at the University of Georgia. Joseph also received a degree from the Lawrence Scientific School at Harvard University. In 1851, he was hired as a science professor at old Oglethorpe in Midway and taught at the school until 1853.

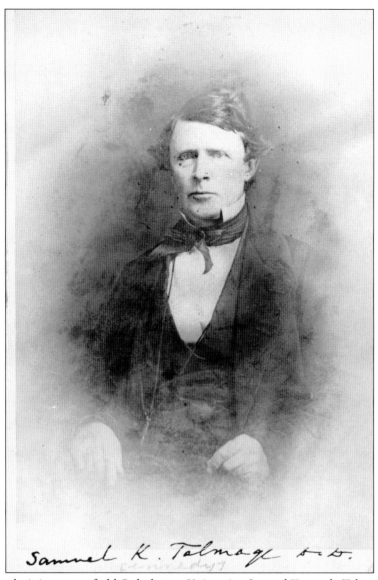

Samuel K. Talmage d.d.

One of the administrators of old Oglethorpe University, Samuel Kennedy Talmage, a native of Somerville, New Jersey, was selected as the second president in 1841. Talmage moved to South Carolina as a missionary after graduating from Princeton Seminary, and by 1828, he was pastor of the First Presbyterian Church of Augusta. His involvement with Oglethorpe began in 1836. Talmage was among the first faculty members and supporters of the young university serving under its first president, Carlisle Pollock Beman. A strong-willed and staunch disciplinarian, Beman resigned in 1840, leaving Samuel Talmage as acting head. The trustees appointed Talmage as the second president in 1841. He served the university as trustee, professor of ancient languages, acting head, and president until his death in 1865. According to an article in the *Westminster Magazine* of January 1915 written by E. M. Green, a former Oglethorpe student, Talmage was a "gentleman of the old school, courteous and kind, of dignified and elegant demeanor, an eloquent preacher, and a scholar of culture and polish." (Photograph compliments of the University Archives, Department of Rare Books and Special Collections, Princeton University Library.)

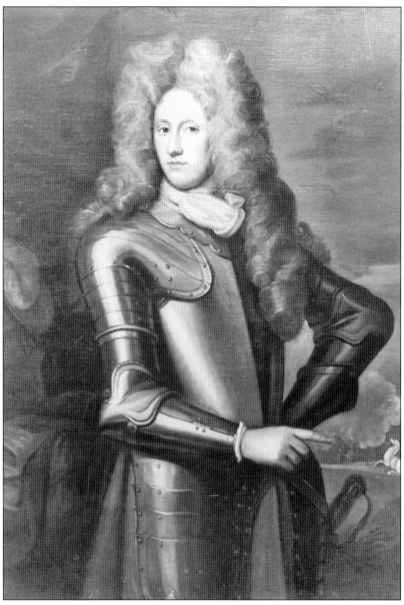

Gen. James Edward Oglethorpe (1696–1785), for whom the university was named, was the founder of the colony of Georgia. He attended Eton, Corpus Christi in Oxford, and a military academy in Paris. While a member of Parliament, Oglethorpe directed his efforts toward prison reform in London. His military experience and philanthropic and humanitarian interests served him well as the first governor of the new colony. Originally designed to buffer the English Colonial desires from the Spanish in the south, Georgia was also established as a colony for those who needed a new place of opportunity to improve their lives. An attempt to bring General Oglethorpe's body and that of his wife to the campus for reinterment was initiated by Pres. Thornwell Jacobs. As the project neared completion, the City of Savannah became involved; the city believed Oglethorpe's body belonged there, the place Oglethorpe first landed in Georgia. The entire process was called off as a result. This painting of General Oglethorpe was donated to the university by Mrs. Joseph M. High.

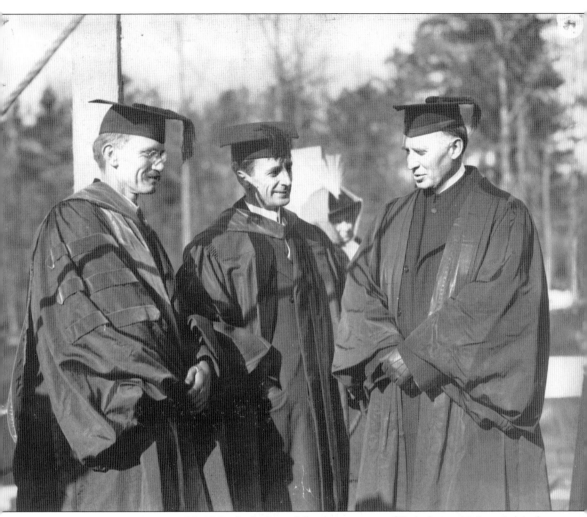

In a ceremony on January 21, 1915, the laying of the cornerstone of Oglethorpe University took place in Atlanta. William Joseph Martin (left), president of Davidson College and moderator of the General Assembly of the Southern Presbyterian Church, and James Isaac Vance (far right), of the First Presbyterian Church of Nashville, participated in the ceremonies along with Thornwell Jacobs (center), who was officially appointed president on April 1, 1915. The festivities began at North Avenue Presbyterian Church at 10:00 a.m. and then convened on campus. Vance inspired the crowd by stating, "Oglethorpe starts with a dowry of freedom. Its face is toward the morning. The strength of youth is in its blood." A letter from Pres. Woodrow Wilson was read by Dr. Martin in which Wilson expressed "a deep interest in the revival of a university which deserves to be cherished by all who are interested in the higher education." According to the February 1915 *Westminster Magazine*, Dr. Vance remarked, "Well, it is laid." Martin replied, "Yes, and may God bless it." The school opened in the fall of 1916 with 45 students.

Thornwell Jacobs (1877–1954), president of Oglethorpe University from 1915 to 1943, fulfilled a boyhood dream by restoring the old college to Atlanta. Trained as a pastor and holding an honorary doctorate degree from Princeton University, Jacobs brought national and international attention to the reestablished university through several of his projects and interests. Some of his initiatives included establishing a medical school, rediscovering the lost grave of Gen. James Edward Oglethorpe, and creating the Crypt of Civilization. His fundraising style linked the school with such benefactors as William Randolph Hearst and John Thomas Lupton. The above painting hangs at Oglethorpe University, and the lower photograph, c. 1915, shows a young Jacobs on the cusp of his time as president at the school.

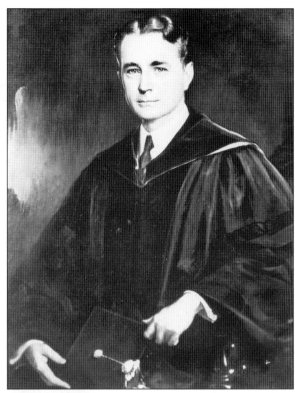

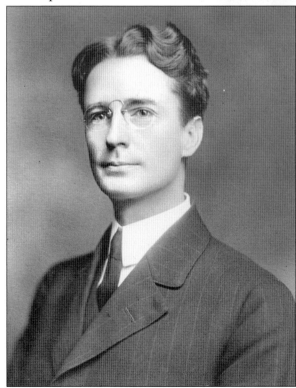

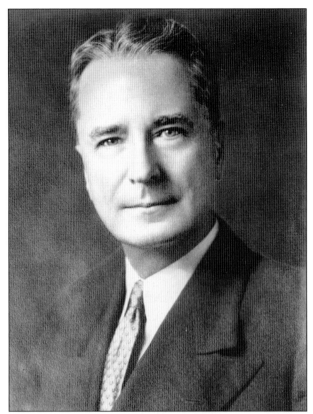

During his almost three decades as president, Thornwell Jacobs worked hard to create and sustain a number of events and activities to ensure a flow of funding to the university, but he was never able to secure a large endowment. During his tenure as president, he conferred honorary degrees on dignitaries and important societal figures including Franklin D. Roosevelt, Woodrow Wilson, and Amelia Earhart. He invited Helen Keller to the campus to receive an honorary degree, but she kindly declined because she had plans to go abroad. In addition to his fund-raising activities, Jacobs started the Oglethorpe press and the *Westminster Magazine*, created and taught a cosmic history class, served as postmaster, and wrote and published numerous books and articles.

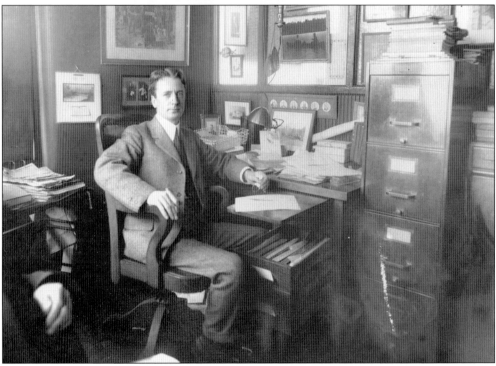

The portrait of Elizabeth Wright Oglethorpe was discovered by Pres. Thornwell Jacobs while on a trip to England. Mrs. Joseph M. High of Atlanta, Georgia, presented the portrait to the university in 1942. The painting, signed by B. Dundridge, provides one of the few known images of the only daughter of Sir Nathan Wright. Oglethorpe married her in 1744 when he was almost 50.

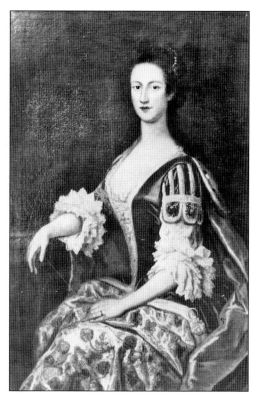

Ernest Hartsock was professor of poetics at Oglethorpe University from 1929 until his death in 1930. Born in 1903, the Atlanta native attended Emory University, receiving an A.B. in 1925. He founded the Bozart Press in 1926 while teaching at Georgia Tech. This literary magazine earned a national reputation. In 1929, he received the award of excellence from the Poetry Society of America for his poem "Strange Splendor."

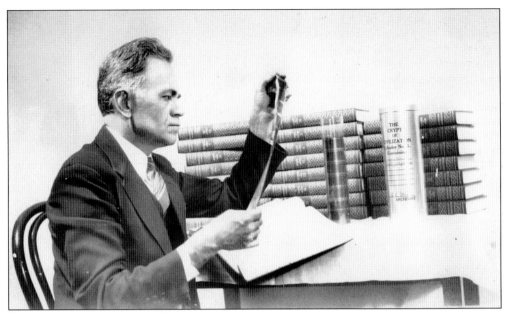

Thomas Kimmwood Peters (photographed above) was born in Norfolk, Virginia, in 1884. With an interest in film and motion pictures, he traveled the world documenting events including the San Francisco earthquake and construction of the Panama Canal. In 1935, after reading of a project devised by Thornwell Jacobs to preserve facts and materials of western civilization in a time capsule at Oglethorpe University, Peters contacted Jacobs and was hired as archivist. During the project, he microfilmed 960,000 pages of reading materials for the Crypt of Civilization. He also developed a system for identifying and collecting materials and applied his knowledge of vacuum sealing. The crypt was sealed on May 28, 1940. Pictured below are books, microfilm reels, and canisters that were used for the project. Peters later retired to California, where he died on December 1, 1973.

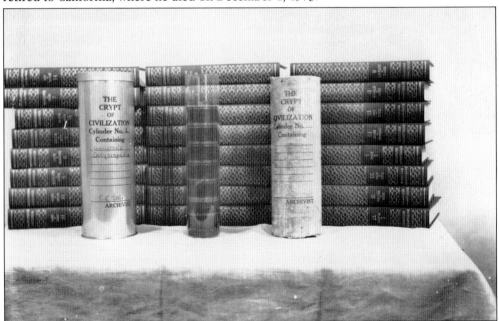

In an effort to meet a growing need for more medical training in the Southeast, Thornwell Jacobs and the board of trustees at Oglethorpe established a medical school in 1941. The son of Thornwell Jacobs, Dr. John Lesh Jacobs (pictured at right), was employed at Tufts College Medical School in Boston when he was asked to become the vice president of the new medical school at Oglethorpe.

An impressive faculty headed by Dr. John Lesh Jacobs, son of Thornwell, was amassed for the new medical school at Oglethorpe, which opened in 1941. Dr. John Barnard, photographed at left, was hired as professor of anatomy. Labs and classrooms were located in Lowry Hall, and arrangements were made for an association with Grady Memorial Hospital.

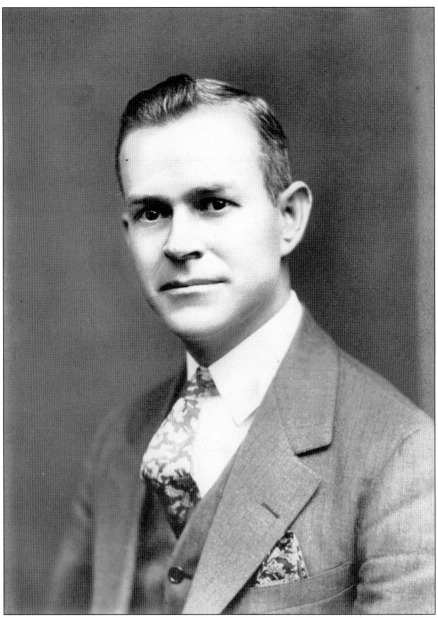

Dr. Herman Jones came on board with the original faculty of the School of Medicine at Oglethorpe University when the school was started in 1941. Jones was serving on the faculty of Auburn Polytechnic when he was asked to join the faculty at the new Oglethorpe medical school as professor of biochemistry; he would later become dean of the school, succeeding Dr. Frank Eskridge. Despite the plans for a superb medical college and the arrangements that were made between Grady Memorial Hospital in Atlanta and the new medical school, many of the efforts to make the school academically solid began to deteriorate rapidly. With the original purpose of the school dedicated to educating and satisfying the growing need for trained medical professionals, the possibilities seemed limitless. However, funding and accreditation became issues immediately, and these two issues would plague the school throughout its short existence. The school was eventually closed on February 11, 1944.

Philip Weltner served as the president of Oglethorpe University beginning in 1944 until 1953. Prior to this appointment, Weltner served as chancellor of the University System in Georgia and member of the state board of regents, a system he was instrumental in founding. He was also involved in penal reform, a concern that was important to James Edward Oglethorpe. A native of New York, he moved to Augusta with his parents, attended the University of Georgia, and received a law degree from Columbia University. Weltner accepted the position at Oglethorpe with the conviction to get it operating again after the strains of World War II. His first challenge came with the struggling medical school, which he closed. Philip Weltner also secured accreditation for the university and began the Core Curriculum idea, which has remained an enduring part of the university curriculum.

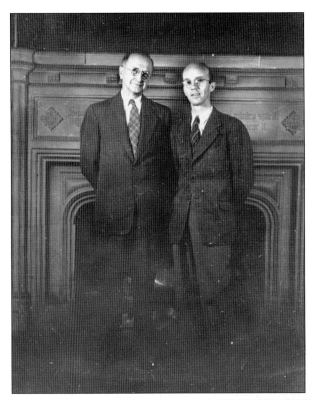

George Seward (right) served as a philosophy professor and vice president under Pres. Philip Weltner (left). Seward received an undergraduate degree from Amherst and a Ph.D. from Tubingen. He left Columbia University in 1944 to join the faculty at Oglethorpe. Seward assisted Weltner in instituting the Oglethorpe Plan of 1945, and he served three times as interim president after the resignations of Presidents Weltner, Wilson, and Bunting. He remained at the university until 1965.

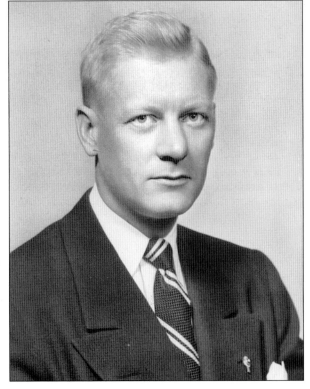

Donald Randolph Wilson became the president of Oglethorpe University in 1956, replacing George Seward, who was acting president. Wilson left a lucrative law practice in Clarksburg, West Virginia, for Oglethorpe. He graduated from Princeton in 1939 and earned a law degree from the University of Virginia in 1942. His presidency at Oglethorpe lasted for 11 months, after which he took a position with the Hearst newspapers in New York.

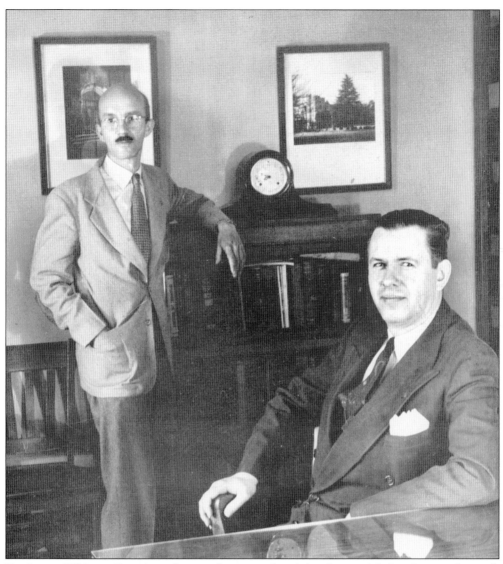

Dr. James Whitney Bunting, shown above on the right along with Dr. George Seward, became president of Oglethorpe on January 9, 1953. Bunting, a native of Philadelphia, held degrees in economics from the University of Pennsylvania and a Ph.D. from the Wharton School of Finance. He served as a lieutenant in the navy during World War II and afterward taught at Hanover College, Hobart College, and the University of Georgia, where he was director of the Bureau of Business Research. He joined the staff of Oglethorpe as executive vice president in 1952. Bunting's short stay was consumed by the growing concern for new facilities. His involvement in local politics quickly became a turning point in his career. Oglethorpe University was located in North Atlanta, an unincorporated "village" chartered in 1925. Bunting entered the race for mayor of North Atlanta defeating the incumbent, F. W. Haas. He took office in 1955 and promptly resigned as president. Three months later, he accepted a position in New York City. Dr. George Seward was appointed acting president during this unexpected turn of events.

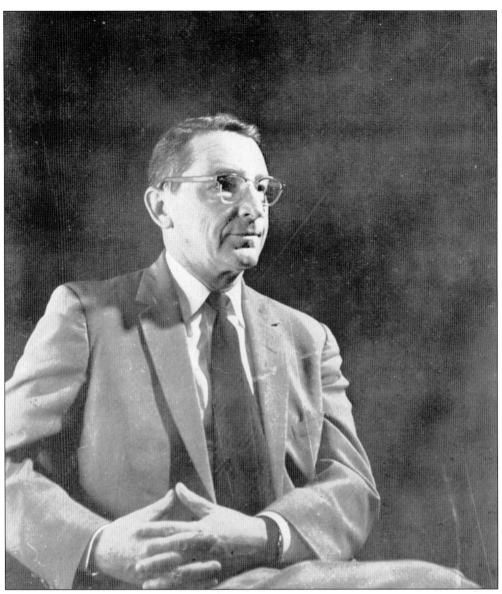

Donald C. Agnew became president of Oglethorpe University on February 12, 1958. A native of Colorado, he was educated at Park College and received a Ph.D. from Duke. He taught at Winthrop College before his career move with the Southern Association. Many of his ideas were adopted by that organization, especially the process of self-study. Agnew became associated with Oglethorpe through Weltner, serving as a consultant on the new curriculum. Upon his return as president, he began a campaign to enlarge the school both physically and monetarily. The night school started in 1964 under his direction. With emphasis on competency and community service, the campus began to grow in a new direction yet retained the traditional ideals of Oglethorpe and its emphasis on service. Under Agnew, the *OU Book* became the *OU Bulletin*, and new classes were added to update the curriculum.

Paul Rensselaer Beall (above photograph, front right), president of Oglethorpe University until 1967, was known as the "Building" president. A native of Iowa, he held degrees from Grinnell, University of Michigan, and Penn State. His inaugural ceremony in 1965 was the first in the history of the school and was attended by 1,000 people representing faculty and students from 156 institutions. Beall's plans called for expansion of the campus.

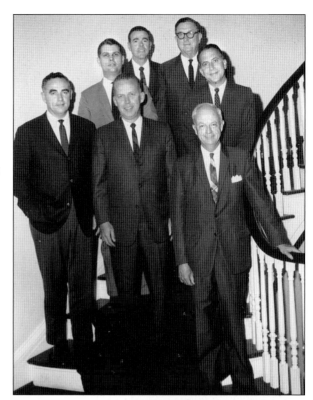

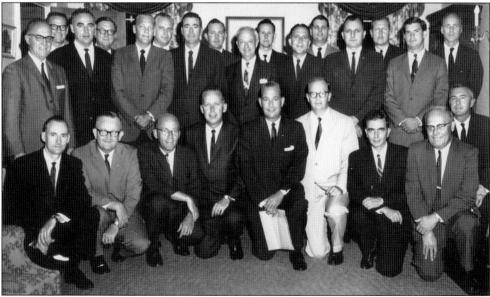

President Beall also emphasized changes to campus administration. He cut the number of divisions in the academic areas, changed their names, and appointed vice presidents to head academic affairs, business affairs, and development. In May 1966, the first President's Council, photographed here, was formed as an advisory group and included 32 of Atlanta's outstanding citizens. Directors were Edward D. Lord, T. Harvey Mathis, Thomas H. Campbell, and Rufus C. Camp.

The son of Pres. Philip Weltner, Charles Longstreet Weltner (1927–1992) followed in his father's footsteps as a lawyer and educator. Born in Atlanta in 1927, he received his B.A. from Oglethorpe in 1948 and a law degree from Columbia in 1950. Charles served as a U.S. congressman from Atlanta and later became an associate justice of the Supreme Court of Georgia. He was well-known for his stand against segregation in the South and his work in seeking social justice. In 1991, Welter was the second recipient of the John F. Kennedy Profiles in Courage award. Like his father, he received the Shining Light award sponsored by WSB Radio and Atlanta Gas Light Company, given to a Georgia citizen whose work served as inspiration. Charles and Philip were the first father and son to achieve this honor.

As president of Oglethorpe University from 1975 until 1987, Manning Mason Pattillo Jr. is known for developing the high standards of academic excellence for which Oglethorpe is recognized. During his tenure, he improved the scholastic quality of both students and faculty and created a sense of campus community, along with achieving an $8 million endowment. With degrees from the University of the South and University of Chicago, his experience in higher education included serving as an officer of the Danforth Foundation and the Foundation Center, and teaching experience at the University of Chicago, New York University, and the University of Rochester. A consultant and lecturer at several universities, he also published numerous articles and books on issues facing academia. He was awarded an honorary doctor of laws degree from Oglethorpe in 1994, which was his seventh such honor from a university.

Paul Kenneth Vonk, president of Oglethorpe University between 1967 and 1975, was a native of Grand Rapids, Michigan, where he and classmate Gerald Ford attended high school together. Vonk held degrees from Calvin College and the University of Michigan. After serving in World War II, he completed a Ph.D. at Duke. He was vice president of academic affairs at both Parsons College and the University of West Florida.

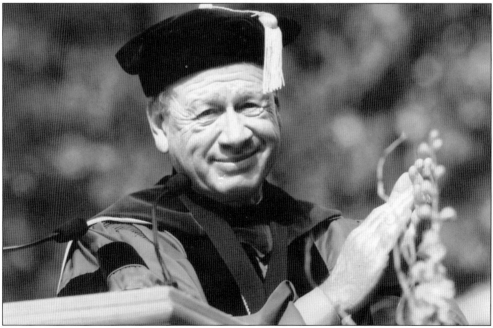

The president of Oglethorpe University from 2000 until 2005, Dr. Lawrence Denton Large was inaugurated on January 13, 2000, in the Dorough Field House. He came to Oglethorpe from Reed College, where he was serving as executive vice president. A native of Idaho, he grew up in the area, served in World War II, and received a Ph.D. from the University of Oregon. Large's career centered on capital campaigns and administration.

Dr. Donald S. Stanton, president of Oglethorpe University between 1988 and 1999, and his wife, Barbie, were regularly seen about campus. Their love for people marked their years at Oglethorpe. Dr. Stanton was inaugurated on November 3, 1988. One hundred and sixty-three delegates from colleges and societies nationwide attended the ceremonies in the Dorough Field House. A native of Baltimore, Maryland, Stanton dedicated his professional life to higher education. He held numerous degrees including an M. Div. from Wesley Seminary, an M.A. in psychology from the American University, and an Ed.D. in education from the University of Virginia. Donald Stanton came to Oglethorpe from Adrian College in Michigan, where he was serving as president. He incorporated his love of travel with his work at the university, making many trips throughout America and abroad to visit and work with alumni and connect with educational institutions. His emphasis was to maintain the significant values from the past, such as a student-centered, personalized educational environment and highly selective admissions. Under Stanton, a revision of the Core Curriculum was completed, major building projects were started (including the Weltner Library renovation), and enrollment improved.

Pres. Lawrence M. Schall officially came to campus on June 23, 2005. His inauguration on April 6, 2006, in the Conant Center included participants from universities throughout the United States. Dr. Schall is also pictured below with the Oglethorpe faculty. Schall, a graduate of Swarthmore College with an Ed.D. and a law degree from the University of Pennsylvania, left his position as vice president of administration at Swarthmore to come to Oglethorpe. Since his arrival, he has energized the campus with programs and plans designed to build community and reinforce the academic rigor for which the college is known. Schall's enthusiasm and belief in Oglethorpe as the best liberal arts college in the South has strengthened its purpose and statement that Oglethorpe students can "make a life, make a living, and make a difference."

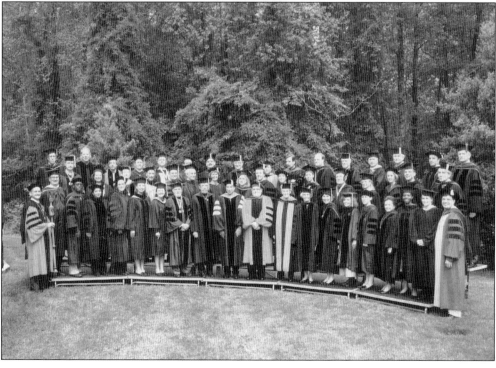

Two

THE OGLETHORPE CAMPUS

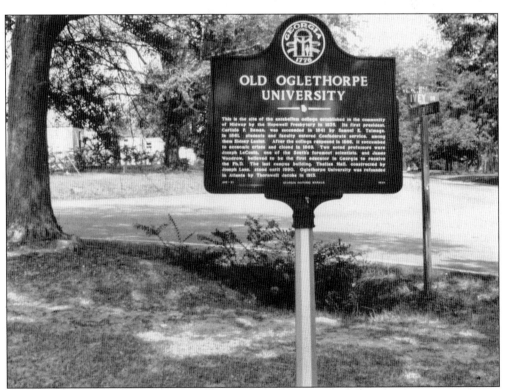

Oglethorpe University grew out of a movement of the Georgia Presbyterians to establish learned institutions in the state. In 1834, one such institution, Midway Seminary, was founded. In 1835, the Hopewell Presbytery became the governing body, expanding the seminary's mission to include classical learning, and thus Oglethorpe University was chartered on December 21. A Georgia Historical Marker, shown above, stands today on the site of the early campus.

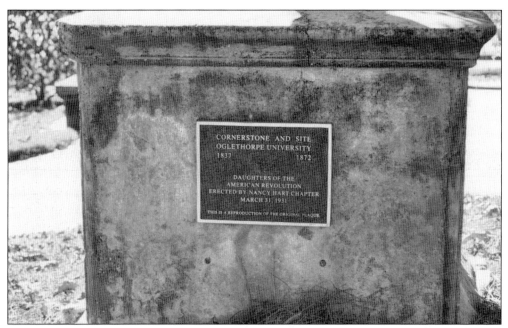

Construction began on the first building, Central Hall, in 1836. The cornerstone, which is shown in these photographs taken in the 1970s, was laid on March 31, 1837. Judge Joseph H. Lumpkin participated in the ceremony. The cornerstone was solid granite and 28 inches by 22 inches. A metal box deposited inside contained newspapers of the period. Classes at the school began on January 1, 1838. The original faculty that was organized in 1836 included Pres. Carlisle P. Beman, Samuel Kennedy Talmage, Nathaniel Macon Crawford, Charles Wallace Howard, and Eugenius A. Nisbet. Names of the college's early incorporators included Thomas Butler King, Tomlinson Fort, Samuel Jones Cassels, Joseph Henry Lumpkin, Eugenius A. Nisbet, and Charles Colcock Jones.

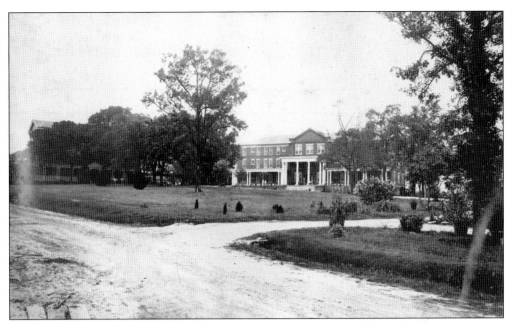

Debating societies were a popular activity of 19th-century campus life. Oglethorpe University had two such societies: the Thalians and the Phi Deltas. The Thalians, the earliest society started in 1839, began successful fund-raising efforts for their own building. In 1859, construction began, and by 1861, the three-story, red-brick building designed by Joseph Lane Jr. was complete. Thalian Hall featured Greek revival architecture, Victorian pediments and entrances, and a wraparound porch. The lower photograph of Thalian Hall, which was taken in the 1980s, documents the original architecture of the red-brick Victorian buildings. The college closed at the start of the Civil War and reopened again briefly, only to close once more in the 1870s. A sanitarium took over the campus in Midway and remained in the buildings for a number of years. (Lower photograph by Thomas W. Chandler Jr.)

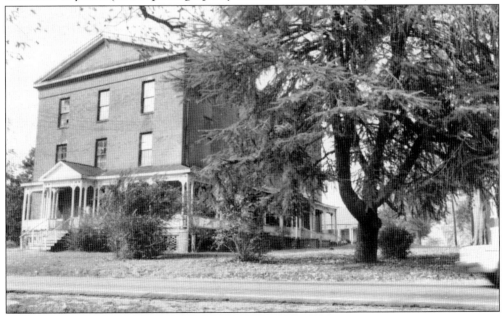

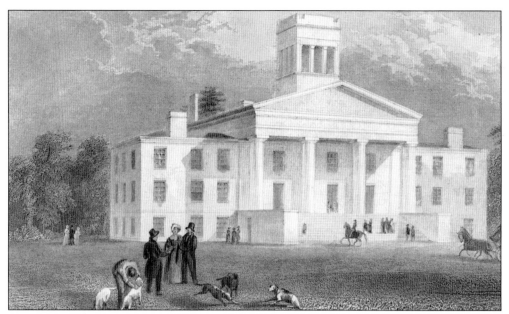

Central Hall, the first building constructed on the Midway campus, was designed by Joseph Lane Jr. The cost was $38,800. It was completed in 1841, but Lane never received final payment. His son Charles attended Oglethorpe and returned as one of the longest-tenured faculty members. Central Hall, constructed in the Grecian-Doric style, was composed of brick painted white and included two stories, with a basement and chapel. (Etching by R. Hinshelwood.)

When Oglethorpe University received its charter on December 21, 1835, the campus contained few buildings. Upon the matriculation of its first class of 25 on January 1, 1838, the facilities included the president's home, several two-room dormitories, as pictured here in this 1970s photograph, and a chapel. The dormitories were one-story, two-room structures, 18 by 18 feet; were built 12 feet apart; and were located in clusters on either side of the campus.

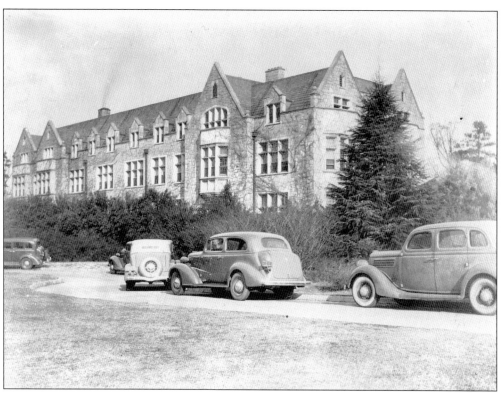

The administration building, photographed here in 1939, was the first structure on the Atlanta campus. The Gothic style of architecture set the tone for future campus designs that were developed in the style of English universities. Atlanta architectural firm Morgan, Dillon, and Downing was selected for the work. The building would be utilized for a number of activities and purposes while the campus developed.

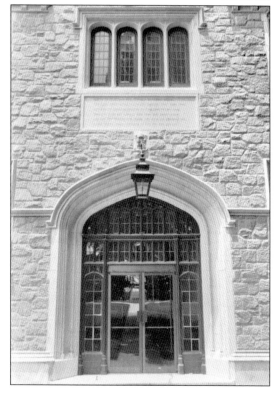

Lowry Hall, designed to house the school of business administration, was built in 1925. Mrs. Emma Markham Lowry provided the funds for the building as a memorial to her late husband, Col. Robert J. Lowry, an Atlanta banker. The Morgan, Dillon, and Lewis design replicated Corpus Christi College, Oxford, which James Edward Oglethorpe attended. Over the door hangs a reproduction Oxford lantern, along with a carving of the coat of arms of Bishop Hugo Oldham.

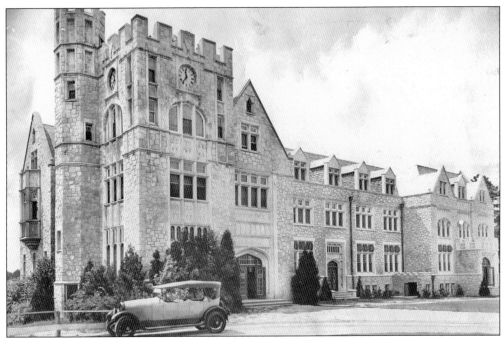

During a fund-raising campaign to refound Oglethorpe University, Thornwell Jacobs met John Thomas Lupton (1862–1933) at the First Presbyterian Church of Chattanooga. Lupton, owner of the Southern franchise of the Coca-Cola Bottling Company, was impressed by Jacobs and his passion to start an institution of higher learning; Lupton wrote a check for $10,000 for the cause. In 1919, he gave another gift of $50,000 to start a second building on campus. Lupton Hall was completed in three parts with ground-breaking ceremonies in 1922, 1924, and 1927. Each portion of the building was named for members of Lupton's family. Lupton Hall has housed an assortment of facilities, including the swimming pool, basketball court, library, classrooms, and dormitories. The final dedication in 1927 was held when the building, complete with bell tower, clock, and chimes, was finished.

When the Oglethorpe university medical school was organized in 1941, Thornwell Jacobs arranged for the students to work with Grady Memorial Hospital, located in downtown Atlanta at Edgewood Avenue and Butler Street. Internships and work within the confines of a major public health facility would provide access to a variety of medical cases. This photograph of one of the clinic buildings on Edgewood Avenue was taken in the 1940s and reflects the pre–World War II atmosphere of the downtown area. Working alongside the personnel at the famous charity hospital in a major metropolitan city seemed like the perfect fit for a new medical school located within public transportation distance of the hospital; however, the arrangements made for the new Oglethorpe medical school did not last. Funding, competition with Emory University's medical school, and administrative problems led to a number of insurmountable obstacles almost immediately upon the opening of the school. The school's failure to achieve accreditation led to its eventual closing in 1944 by Pres. Philip Weltner.

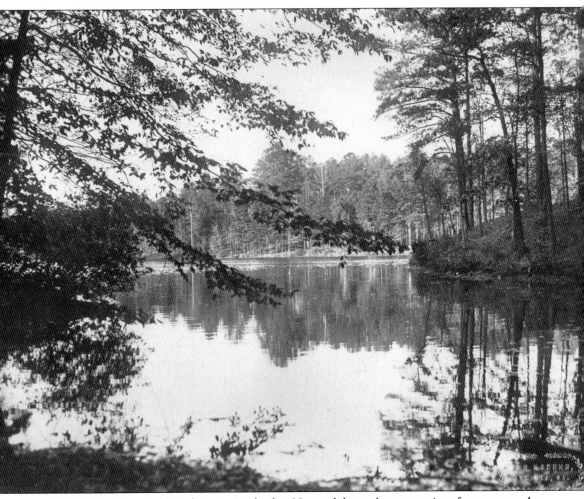

In 1911, the Silver Lake Park Company built a 28-acre lake as the centerpiece for a soon-to-be-developed real estate project. An early advertisement for Silver Lake Estates publicized it as a "splendid Presbyterian community." Arrangements were made for the Oglethorpe students to use the lake. Later William Randolph Hearst bought the lake and surrounding property for the university; the lake was renamed Lake Phoebe in honor of his mother. Oglethorpe University remained the owner of the lake for a number of years, making provisions for the community to use and enjoy it, and a variety of water sports and activities were available. The property was eventually sold. In 1977, the Toccoa dam disaster occurred, which resulted in the loss of many lives. The State of Georgia responded with a movement to inspect dams throughout the state. The result was the destruction of the Silver Lake dam and the drainage of the lake. Over the next few years, residents of the community and John Knott, dean of administration, successfully mobilized and privately funded the restoration of the lake. (Photograph by Ken Rogers, Atlanta.)

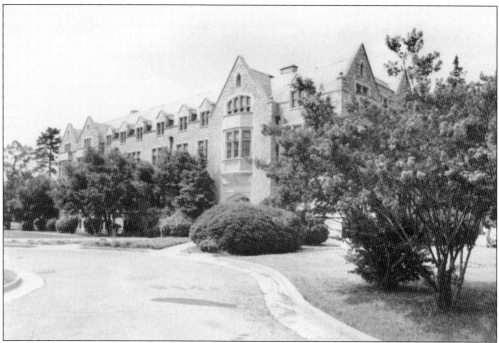

Phoebe Hearst Hall (above) contains the Great Hall (below). The elaborate wooden staircase and panels in the hall are a signature of the architectural design and detail of Walter Thomas Downing. Downing, a member of the firm Morgan, Dillon, and Downing, was the son of English immigrants who came to Atlanta in the 19th century. His taste reflected his English heritage. His love of the Tudor and Gothic styles are reflected throughout the numerous homes and buildings he designed in Atlanta. Hearst Hall, the first building on campus, which was originally called the administration building, was constructed of Indiana limestone, granite from Stone Mountain, brick, and tile, with steel and concrete floors.

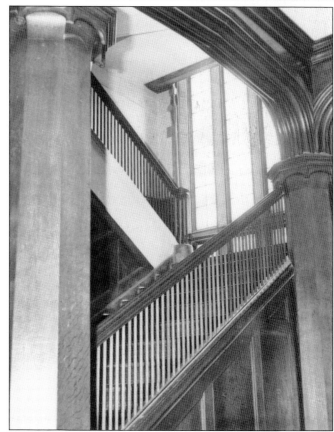

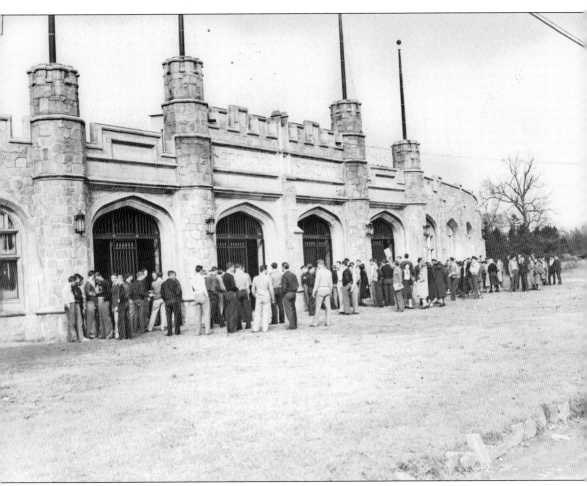

Athletics became a major emphasis of college life beginning in the 1890s. Pres. Thornwell Jacobs, eager for Oglethorpe to acquire winning teams, started an athletics program in 1916 with basketball, and later football and baseball were added. Under the direction of athletics director Frank Anderson, the program flourished. During the 1920s, the Petrels played a series of football games against Georgia Tech, with victory arriving at last on September 25, 1926, with a score of 7-6. Also in the 1920s, Harry Putnam Hermance donated $50,000 to be delivered over several years for the construction of Hermance Stadium. Harry, his wife, Sybil, daughter Helena, and son Hal attended the dedication game between the Flying Petrels and Dayton Flyers on October 26, 1929. The Petrels won 20-12. The stock market crashed a few days later, ending the family's fortune and the completion of the stadium. The field would later be converted into a baseball field named Anderson Field in honor of coach Frank B. Anderson.

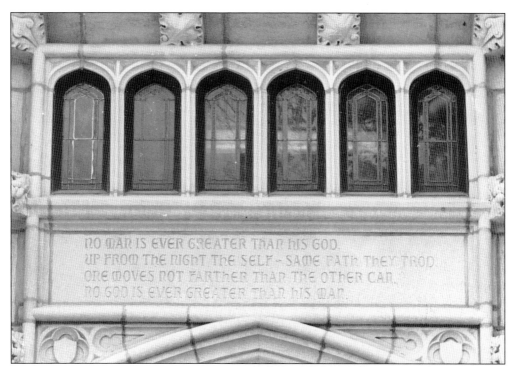

NO MAN IS EVER GREATER THAN HIS GOD.
UP FROM THE NIGHT THE SELF - SAME PATH THEY TROD
ONE MOVES NOT FARTHER THAN THE OTHER CAN.
NO GOD IS EVER GREATER THAN HIS MAN.

In 1914, Thornwell Jacobs wrote a brief four-point report to the executive committee requesting that the architecture and landscaping of the university remain in the tradition of the great English institutions. This included incorporating the Gothic style with the use of stone, which was readily available in Georgia. Throughout the campus, the "silent faculty," as he referred to the buildings, would teach and inspire students through the visual harmony between buildings and landscape. Utilizing the theme of the "silent faculty," Jacobs had his own words of inspiration carved over the doorways of several buildings, including Lupton, Lowry, and Hearst Halls. Even the athletics stadium was thoroughly detailed with appropriate medallions to carry forth the same look and feel of the dignified and beautiful "silent faculty."

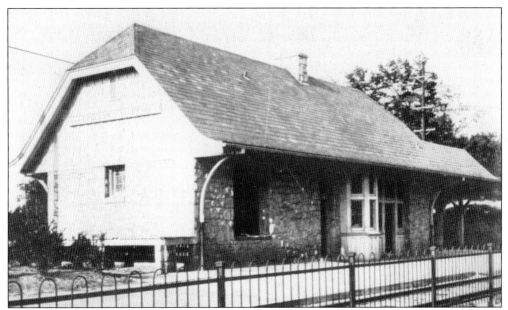

Thornwell Jacobs began raising money in 1917 to build a railroad station for Oglethorpe (pictured here in the 1940s). Morgan, Dillon, and Lewis designed the building to complement the campus. Jacobs called 1917 the year of transportation because the federal government was expanding Peachtree Road to reach Camp Gordon and the streetcar service was extended farther north on Peachtree. In 1977, the station, owned by Southern Railway, was razed to accommodate MARTA (Metropolitan Atlanta Rapid Transit Authority).

Goodman Hall was built between 1955 and 1956 as a men's dorm. The building cost $120,000 and included modern amenities such as built-in bunks, picture windows, a sunken fireplace, and Plexiglas skylights. It was named in memory of Charles Goodman, a trustee and benefactor of the university from 1945 until his death in 1955. In recent years, it has housed the evening-program and information-technology departments. (Photograph by Bob Wyer Photo Cards.)

40

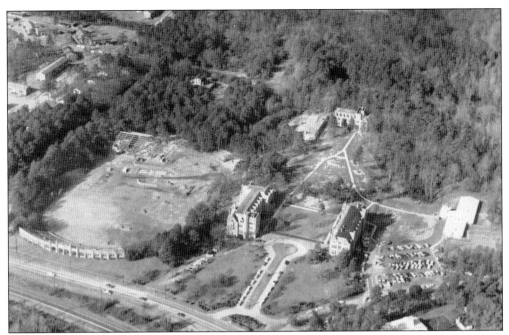

The above aerial view shows the campus before the building campaign of the late 1960s and early 1970s added structures. Beginning in the 1950s, there came a need to expand the campus, including athletic facilities, a science building, and more dormitories. After funds were acquired, including private donations and federal grants, the aggressive building program and renovation of existing buildings began. The majority of these improvements were made between 1969 and 1971. The lower photograph shows the addition of four-sided Traer dorm on the upper right and Goslin Hall on the upper left. (Lower photograph by Joseph P. Sebo Jr.)

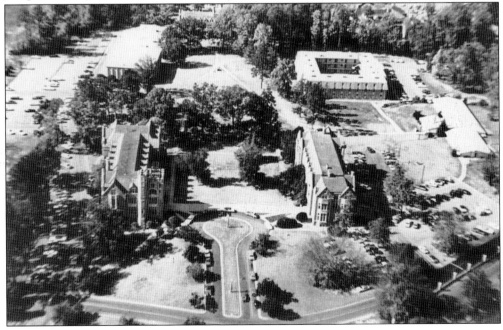

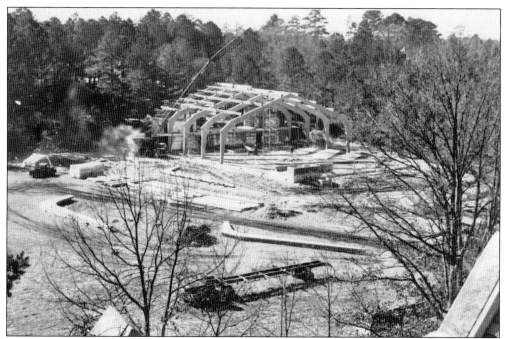

The long-awaited field house, later called the Dorough Field House, was dedicated on Alumni Day in 1960. The dream had begun as early as 1954, with alumni and students backing the idea and continually pressing for its priority in the campus plans. Construction, which is shown above and below, began in 1959 on the much-needed athletic facility. The new building was designed to blend in with the existing campus. The seating capacity inside was 2,100. A $15,000 donation from Coca-Cola's L. F. Montgomery in memory of his wife, Jeannette Lowndes, paid for the bleachers. (Lower photograph by David Allen.)

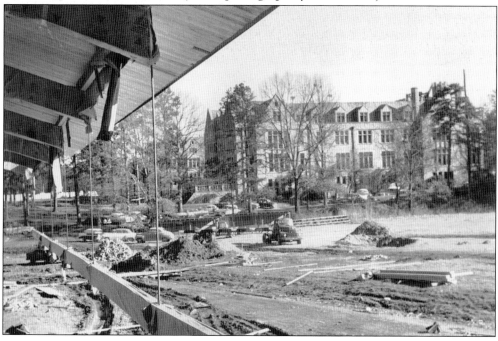

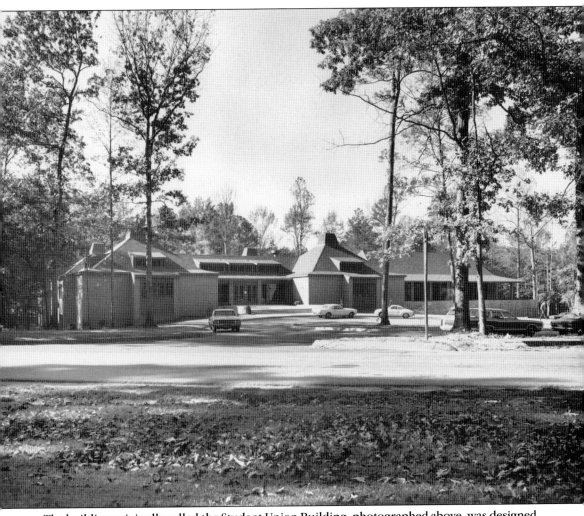

The building originally called the Student Union Building, photographed above, was designed by Sheetz and Bradfield in 1966 in a French provincial style. It was completed in 1969 and opened in June of that year. The name was quickly changed to the College Center. The newly appointed building, complete with a ski lodge–like interior, housed a suite of student government offices, a darkroom for the *Stormy Petrel* newspaper and Camera Club, snack bar, dining hall, lounge areas, and recreational facilities. The Department of Admissions and offices of the dean of students, dean of men, public relations, and conference director were also located there. A 20-by-60-foot swimming pool next to the building became one of the new landmarks for the opening of the 1969 school year. The pool was removed to make way for the construction of new dormitories, which were started in 2006. (Photograph by Jerome Brown, Atlanta.)

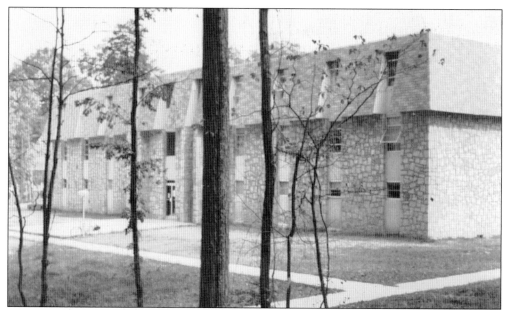

Built as a state-of-the-art dormitory for female students, Traer Hall has also served as a freshman-only dormitory. Originally built in 1969, it hosted 115 rooms with carpet, air-conditioning, and a neo-Gothic architectural style. The building was named in honor of Mary Traer, daughter of alumnus Wayne Traer, who assisted with a grant to make the building possible. Traer Hall was refurbished in 2005.

Made of World War II surplus materials, this building was used for chemistry students until Goslin Hall opened in 1971. Known simply as the "temporary chemistry building," it was reminiscent of the frame dormitories of the Midway campus. The building sufficed for years, with students using additional space in the basement of Lowry Hall for laboratories. In the 1960s, a $128,733 Office of Education grant helped jump-start construction of a new building.

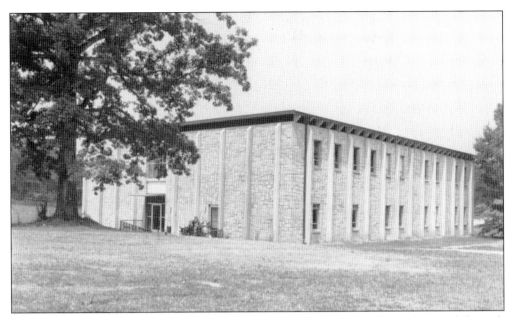

In the 1960s, funds for the new three-story science center were completely financed through government and foundation grants. The ground-breaking ceremony was held on February 16, 1971, followed by the dedication on October 20. It was named for Dr. Roy Goslin, Oglethorpe professor of physics beginning in 1946. In 1944, while Goslin was teaching at Alabama Polytechnic Institute, he was called to work on the famous Manhattan Project.

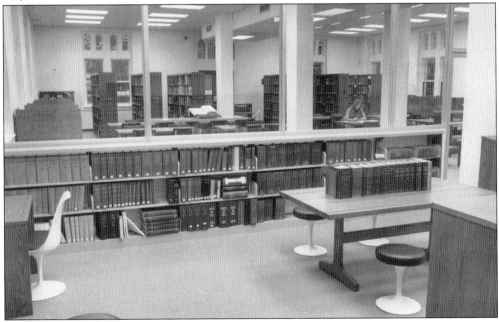

Librarian Tom Chandler, who joined the faculty during the administration of President Agnew, expanded the library collection to the point of outgrowing the space allocated in the Lupton Hall library. As part of the building improvements of the 1960s and 1970s, Lowry Hall was renovated to house the library. The refurbishment included new furniture, study areas, and offices, as pictured above. (Photograph by Jerome Brown, Atlanta.)

The two houses in these photographs, the Sigma Alpha Epsilon House and the Beta Nu House, represented the state of the Greek life prior to the relocation of Greek housing back on campus. In 1989, the decision was made to sell surplus land between Lanier Drive and Ashford-Dunwoody Road where the Chi Omega, Delta Sigma Phi, Kappa Alpha, and Sigma Sigma Sigma houses were located. Beginning in 1993, plans were made to build new houses. The $1.2 million project was approved by the board of trustees in February 1993, and construction of six 3,000-square-foot houses designed by Roberts-Collins Architects began in April. The relocation was a positive means of inserting the Greeks and their activities into the campus life in a more direct way while providing housing for some 48 students. In 1994, four fraternities and two sororities officially moved into the new housing. (Photographs by Jerome Brown.)

The Miriam H. and John A. Conant Performing Arts Center was officially dedicated on May 2, 1997. The Georgia Shakespeare Festival held its first performance there in the opening season of 1997. The center was designed for use by Oglethorpe students, performing arts groups, and the Georgia Shakespeare Festival. The $5.4 million facility contains a 510-seat theater, a lobby and reception area, box office, two rehearsal areas, a green room, and extensive dressing rooms and offices.

The Sheffield Alumni Center was dedicated on March 10, 2001. The naming of the center was a surprise to O. K. Sheffield, class of 1953, whose generous donation made the renovation possible. The house, originally the home of the Oglethorpe president, became available during the presidency of Dr. Larry Large, when the president's home was relocated to Mabry Road. Sheffield and Large worked together with the Buildings and Grounds Committee to make the alumni center a reality.

In the 1940s, ground was broken by Mrs. Hugh N. Bancker, president of Oglethorpe's Women's Board, for Faith Hall. The process began with only $3,000 and the faith of Pres. Thornwell Jacobs. On May 17, 1942, Bancker placed a copper box in the cornerstone following the 23rd commencement, yet $35,000 was still needed to complete the building. In 2000, J. Mack Robinson gave funds to finish what is now named Robinson Hall in his honor.

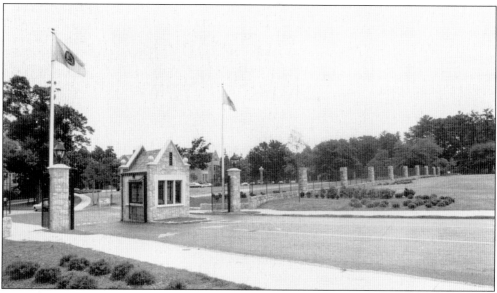

The gatehouse was not in the original plans of the university. The original driveway offered a panoramic view of Lupton and Hearst Halls and included a median with lampposts. The gatehouse pictured here was completed in 1980 to replace the old "guard-post" gatehouse; it was called the only collegiate Gothic gatehouse with a design chosen to reflect the existing campus buildings with their feeling of "strength and integrity." It was named in honor of Elgin MacConnell, dean of administration.

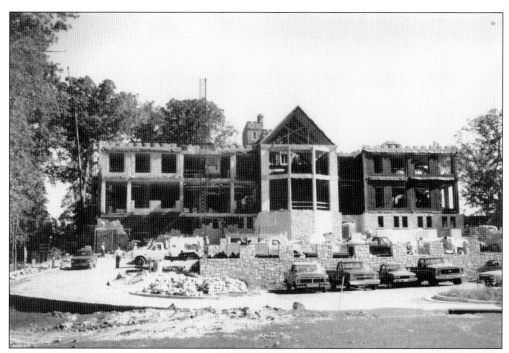

Completed in 1991, the library addition to Lowry Hall incorporated the impressive outer architecture into the new interior reading room. Following a remarkable design created and executed by the firm of Cherry Roberts, the addition was built in the Gothic style of the original Lowry Hall. The dedication ceremony took place on September 17, 1992, at which time the library was named for past Oglethorpe president Philip Weltner. The addition provided much-needed office and stack space, in addition to audio-video rooms, listening stations, the Earl Dolive Theatre, and individual study rooms. Construction of the addition is shown from the rear of the building (above) and through a window of Lowry Hall (below). The hall has often been referred to as the most beautiful building on campus.

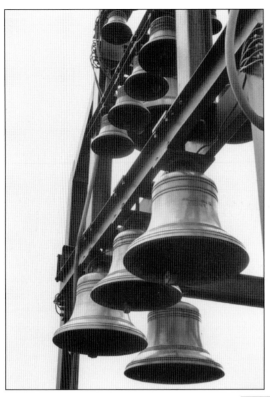

"Given by Grace Josephine Lesh, that the hours at Oglethorpe might be filled with music and harmony" reads the inscription on the largest of the original four bells donated by Lesh, sister of Maude Jacobs, who was the wife of Pres. Thornwell Jacobs. The Lesh gift of 1922 was soon followed in 1929 by another generous donation of a fifth bell by Mrs. J. M. High of Atlanta. At the time, five other bells were added, bringing the total to 10. When the tower needed restoration in 1972, the 10 bells were removed in January and shipped to Cincinnati, Ohio, for sounding. In December of that same year, they were restored to the tower by a huge crane. Twenty-five new bells, cast in Holland by Petit and Fritzen, were added at that time. The carillon is shown above, and below on top of Lupton.

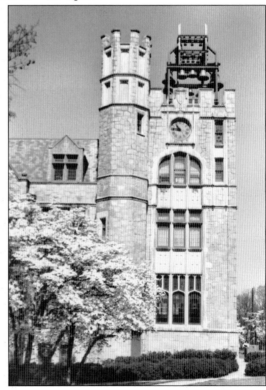

Three

STUDENTS

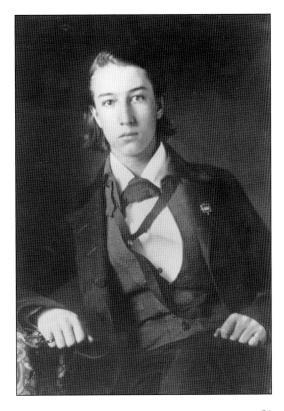

Sidney Lanier (1842–1881), famous poet, musician, and critic, is Oglethorpe's most distinguished alumni of the antebellum era. Lanier was born on February 3, 1842, in Macon, Georgia, and he enrolled at Oglethorpe in January 1857. During his time as a student, he joined the Thalian Literary Society and also formed close ties with Prof. James Woodrow, a distinguished scholar and uncle of Pres. Woodrow Wilson. (Courtesy of the Ferdinand Hamburger Archives of Johns Hopkins University.)

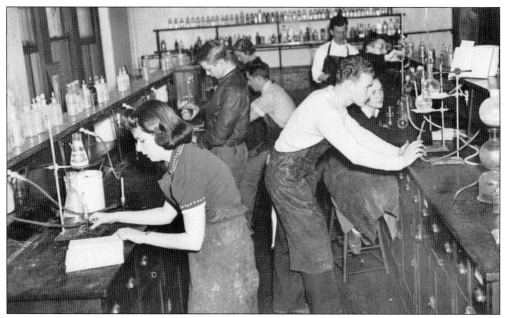

This photograph, taken in 1939, shows Oglethorpe students in a science laboratory. Science classes in the late 1930s and early 1940s generally consisted of three lectures a week with four hours of laboratory. The School of Science offered a bachelor of arts degree and provided a strong science background for students entering into such professions as agriculture, engineering, medicine, dentistry, and the natural sciences.

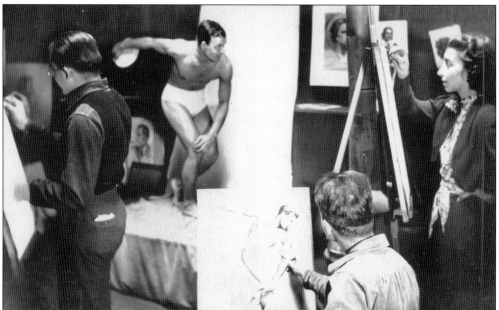

In the late 1930s, the School of Fine Arts offered degrees in art education and a diploma in art, designed for students wishing to pursue commercial and industrial art professions. The school offered drawing from life and figure sketching courses, which required art students to learn to draw figures in actions or poses. The classes occasionally utilized live models for assignments.

These two images from the 1920 *Yamacraw* yearbook show a typical student bedroom and one corner of the dining room. The second and third floors of the administration building (later named Hearst Hall) were used for student dormitories in the early years of the university. The rooms for students provided furniture made of oak, including a chest of drawers, a study table, and a bed with a mattress. The dining room of the university, which could seat up to 250 people, was also located in the basement of the administration building. In addition, the basement included the kitchen, food and dish pantries, a laundry room, and three rooms that were used by the School of Commerce.

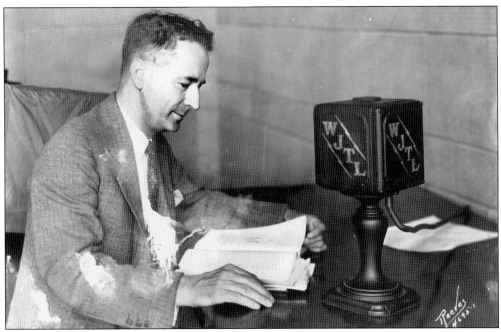

On June 6, 1931, Pres. Thornwell Jacobs attracted national attention to the university by beginning the first college or university radio station in the nation. The campus radio station, WJTL, was named after Oglethorpe benefactor John Thomas Lupton and would operate for five years. At first, the radio station was located in Lupton Hall, and the entire biology department was moved from Lupton to Lowry Hall in order to make room for the new radio division and its large studios and transmitting and control room. A typical broadcast day included a devotional program, music, and 50-minute lectures by Oglethorpe faculty, including complete courses of economics, beginning German, and English. After a few months, the station was moved from Lupton Hall to a Shrine Mosque in downtown Atlanta. Dr. Jacobs (above) and a student (below) are captured in these *c.* 1932 images.

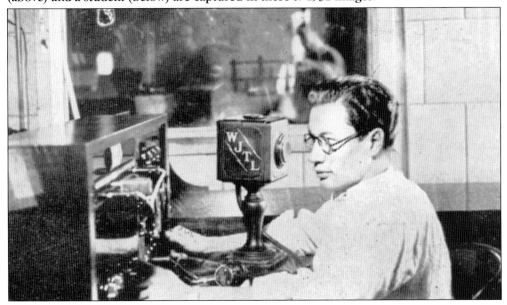

Steven J. Schmidt, class of 1940, served as a World War II pilot in the Pacific, where he flew 15 missions. Schmidt is shown here with his plane, which he named the "Stormy Petrel" after Oglethorpe's mascot. Orphaned at the age of 10, Schmidt later attended Oglethorpe on a football scholarship. In the early 1960s, he was inducted into the Oglethorpe Athletic Hall of Fame, and in 1992, he was accepted into the Georgia Sports Hall of Fame. Schmidt became an Oglethorpe trustee in 1963 and served as chair for 14 years. He was known as "Mr. Oglethorpe" and was recognized by the university with an honorary doctor of laws in 1986. In 2006, a portion of Peachtree Road was dedicated as Stephen J. Schmidt Memorial Highway, in remembrance of this benefactor and friend of the university.

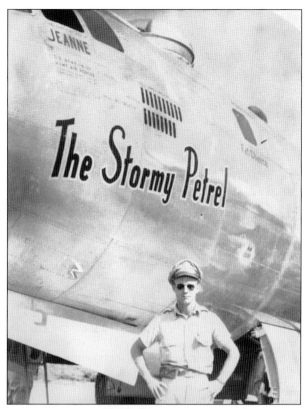

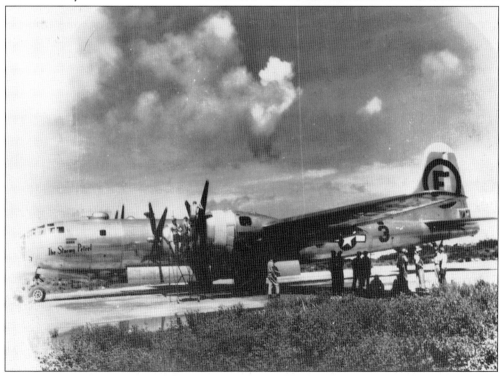

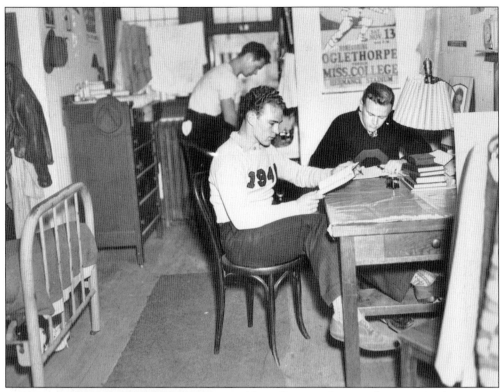

This photograph was taken in a student dormitory in 1939. During that time, dormitories were located in the second and third floors of Hearst Hall, the third floor of Lupton Hall, and the second and third floor of Lowry Hall, which most recently is the location of the Philip Weltner Library and the Oglethorpe University Museum of Art.

Students in 1949 had five organized dances they could attend. The Masquerade Ball and Christmas Formal were held in the first half of the school year, while the Oglethorpe Ball, Black and White Ball, and Spring Formal were held in the latter half of the year. Students are seen here congregating around a punch bowl at an Oglethorpe event c. 1948–1949.

The medical school of Oglethorpe University was founded in the summer of 1941 during the presidency of Thornwell Jacobs. In its opening year, the medical school attracted over 50 students from around the nation. In their first year, the medical students took courses in anatomy, biochemistry, and physiology, while the second-year studies included pharmacology, pathology, and bacteriology. For a short time, Oglethorpe's medical school opened a downtown establishment that provided medical treatment for people unable to afford care by a private physician or hospital. The school closed two and a half years after its founding because of lack of accreditation. The top photograph, *c.* 1942, shows Oglethorpe medical students and faculty in Oglethorpe's academic quad. The bottom photograph, also *c.* 1942, shows a medical class, which were mostly held in the basement of Lowry Hall.

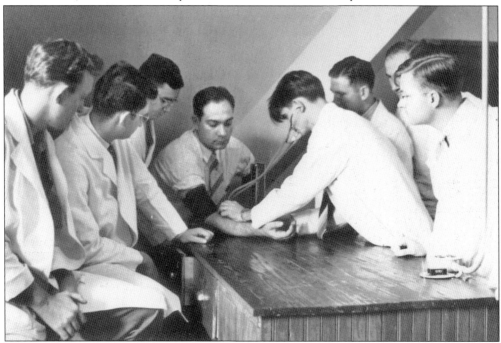

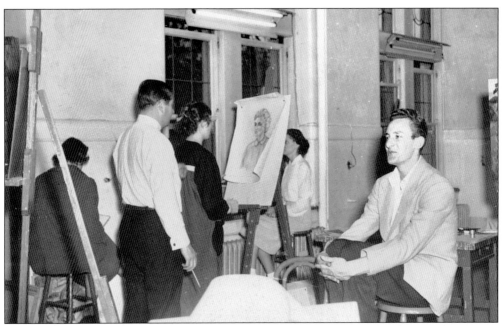

During Dr. Philip Weltner's time as president, the art courses at the university were mainly taught by R. Crawford Livingston, professor and chairman of the fine arts. Livingston was himself an artist, and he was perhaps best known for his *Havana Holiday* series of paintings, which featured brightly colored scenes from one of his trips to Cuba. His paintings were published in a few magazines, including a 1952 edition of the *Atlanta Journal and Constitution Magazine*, which also featured an article by Livingston describing his experience traveling in Cuba. An Oglethorpe art class creating student portraits is captured in the above photograph; R. Crawford Livingston is standing, wearing a white shirt, looking at a student's composition. Below, Livingston (right) is shown in the Oglethorpe art gallery with three students.

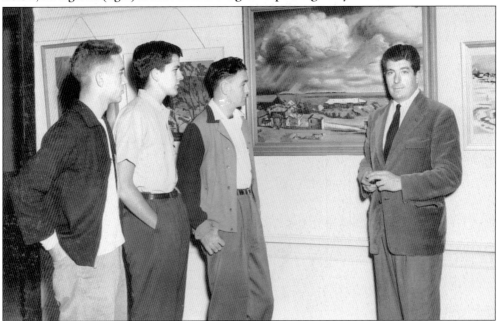

Dr. Arthur L. Cohen (top photograph, second from left) is shown with Oglethorpe students on a science field investigation of a lake environment, *c.* 1950. Cohen was a science professor at Oglethorpe from 1947 until 1962, and he encouraged his students to become engaged in scientific research and pursue advanced degrees in the scientific fields. Dr. Cohen also was involved in the student science organization at Oglethorpe, the LeConte Society, which was named in honor of a science faculty member of old Oglethorpe University in Midway, Georgia. The lower photograph shows students resting and enjoying a meal after their day of science investigation.

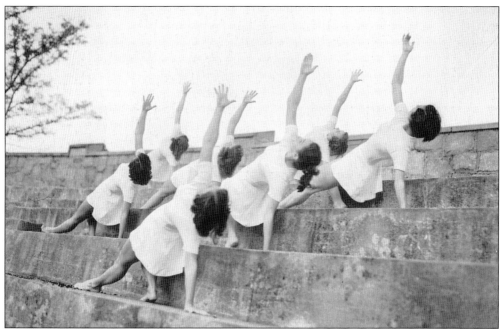

A modern dance class practicing in Hermance Stadium is shown in the above 1952 image, and a typical female dormitory is show below, *c.* 1949. During the late 1940s and early 1950s, female students had to abide by more regimented regulations than the male students. Females were to be in their dormitories by 7:00 p.m. during the week unless they had permission from the house mother or were signed in at the library. The women also had to receive authorization and sign in and out whenever they left campus. In addition, a student telephone monitor was on duty in the female dormitories to answer the hall phone and to make sure that student telephone calls were limited to five minutes.

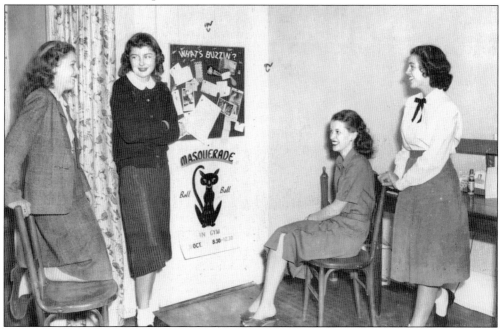

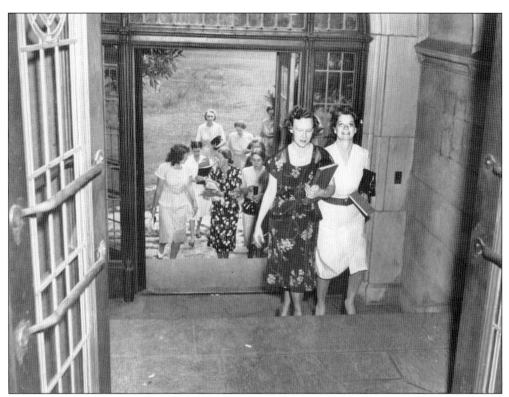

The Great Hall, located within Phoebe Hearst Hall, has long been one of the most popular places for students to socialize and take breaks from studying. In the early days of the university when dormitories were located within the building, the Great Hall was considered the students' living room, complete with a fireplace and couches. The Great Hall also has served as a place for campus events to be held. The top photograph captures female students entering the Great Hall of Hearst in the early 1950s, while the lower image shows students lounging and socializing on the stairs of the building, outside of the hall.

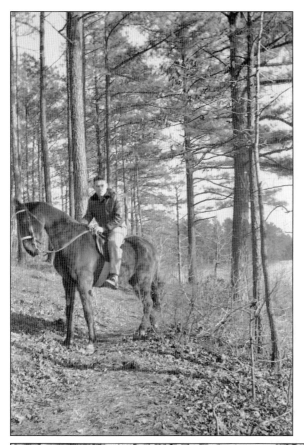

Horseback riding was part of the men's and women's intramural programs at Oglethorpe for a few years during the late 1940s and early 1950s. A small stable was conveniently located on campus and was used by both the intramural students and students who rode for recreation. At the time of these 1950 photographs, Oglethorpe owned the Silver Lake area, which was then known as Lake Phoebe. The wooded area offered numerous riding trails to follow. The above image captures student Lee Wilson on a horse, and the photograph below shows Dudley Engelson (left) and Sheldon Fleitman standing with a horse.

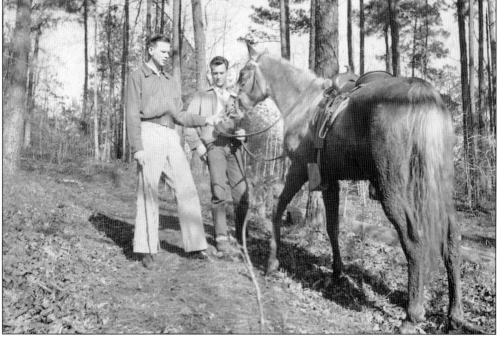

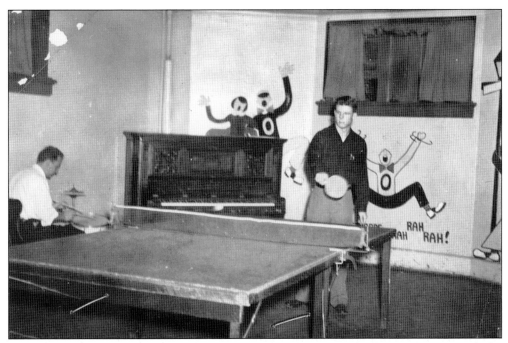

The play room of Oglethorpe University was a popular hangout for students during the late 1940s and early 1950s. The play room walls were painted with cartoon murals, and the space was used for the playing of cards and games, studying, and Ping-Pong tournaments, as is seen in the above photograph. The room also had a piano and was sometimes used for informal dances and band performances. The lower photograph, taken in the play room in 1949, shows the group the Quintettes. The group was led by Oglethorpe student Jerry Quin, who was a junior at the time of this photograph.

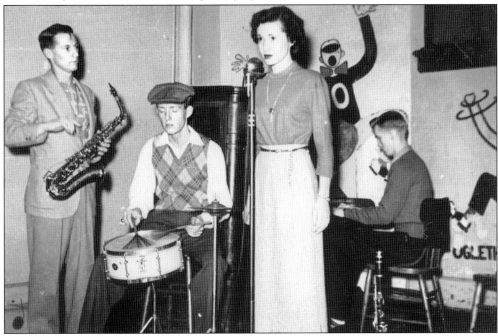

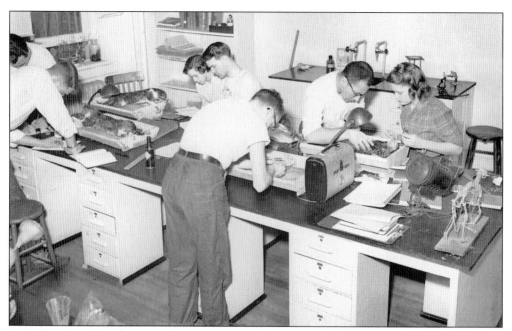

In 1950, when this photograph was taken, the science division of the university was led by Professors David Camp, Roy Goslin, Lois Williamson, Charles Rice, and Arthur Cohen. In the early 1950s, a bachelor of science degree was awarded to students who had completed at least one-fourth of their 194 required course hours in science. This scene shows students dissecting in a biology laboratory.

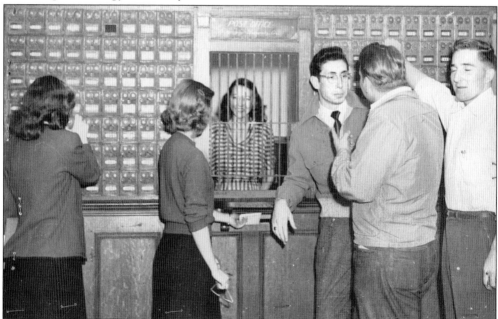

For many years, Oglethorpe had its own post office, which was located within the administration building and was run by an official postmaster. For a year after his resignation as president of the university, Dr. Thornwell Jacobs worked as the postmaster until the end of the 1944 school year. Students are shown in this c. 1949 photograph in the mail room.

The top image displays a shot of the academic quad on graduation day in 1951, which was held on Sunday, June 10. The graduation day began with a Sunday morning service that included hymns and a sermon by the pastor of the Oglethorpe Presbyterian Church. During the afternoon, the graduation ceremony was held and degrees were presented by Dr. George Seward. Dr. Elliot Cheatham, professor of law at Columbia University, gave an address and was presented with an honorary degree. Following the ceremony, a reception was held for the graduates in the Great Hall of Hearst. The lower image, also taken in 1951, is of the Capping Ceremony. The Capping Ceremony was held early in the fall semester to symbolize the formal opening of the university and to celebrate the start of the seniors' final year.

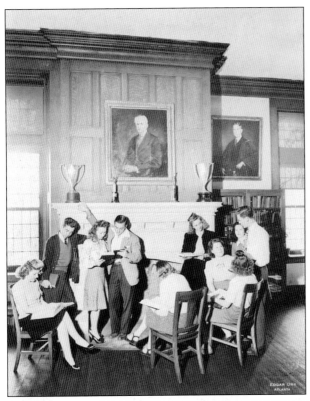

During the late 1930s, when these photographs of the Lupton Hall library were taken, library economy courses were offered as part of the School of Literature and Journalism curriculum. The courses met three times a week and were designed to instruct the students in the use of the decimal classification system and the card catalogue. A section on filing was also given to benefit secretarial preparation students. The library courses also aimed to introduce students to the best reference books for each subject. (At left, courtesy of Edgar Orr, Atlanta.)

During the 1960s, "Rat Week" was held as part of the freshmen student experience. After freshmen orientation ended, Rat Week began, and its purpose was to encourage unity among the freshmen. In 1964, when this photograph was taken, the freshmen were assigned paddles and gold-and-black hats, and they were to wear the hats until Oglethorpe won its first basketball game.

New Oglethorpe students are shown at freshmen orientation in this *c.* 2000 photograph. During the orientation, students participate in team-building games, which encourage them to build ties with one another. Student orientation days often include a student activities involvement fair, a tour of Atlanta and the Oglethorpe campus, a student mixer, and a reception at the president's home.

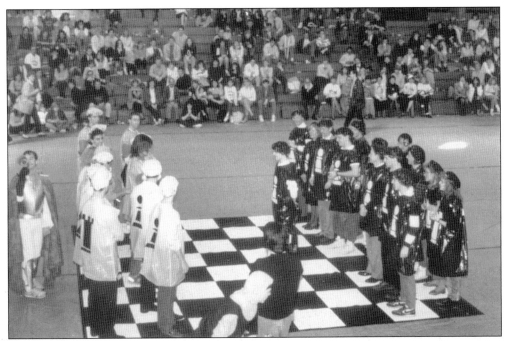

The celebration of Oglethorpe Day began in 1954, when the faculty of the university passed a resolution to celebrate the occasion each February 12, which was the day the colony of Georgia was founded in 1733 by James Edward Oglethorpe. In 1988, as shown in the above photograph, Oglethorpe Day included a life-size chess match complete with water balloons and pies. Oglethorpe students, faculty, and staff served as chess pieces. A graduation during the presidency of Larry Large (1999–2005) is shown in the lower photograph. The ceremony was held outside in the academic quad area.

The official fight song of the university, the "Stormy Petrel March," was written by W. F. Underwood and Jack Cathcart in 1924, and it was arranged in 1987 by Dr. W. Irwin Ray, director of musical activities of Oglethorpe University. The university mascot is the Stormy Petrel, a seabird found on the Eastern Seaboard that is known for gliding close to the ocean's surface. According to legend, James Edward Oglethorpe was inspired by the courage of the small bird as it soared over and dove into the ocean waves as he crossed the Atlantic Ocean in 1732. In March 2002, ESPN's David Lloyd named the Stormy Petrel as one of the most memorable college mascot names of all time. The mascot, shown above, is affectionately known as "Petey" by the students.

Come on ol' Oglethorpe
We're going to take the lead,
Our flag will fly on high
And help us now succeed.

We'll wave the Black and Gold
And fight with all our might.
Oh! Stormy Petrel! Stormy Petrel!
Fight! Fight! Fight!

The Oglethorpe alma mater has changed during the course of the university's history. During Thornwell Jacobs's time as president, the anthem was the longest in the university's history with three stanzas, each with eight lines. The song was a tribute to Gen. James Edward Oglethorpe, and it compared the general's ideals to those of the university and its students. During Philip Weltner's presidency, the alma mater was two stanzas, and it described the beauty of the school and the feelings students have when they graduate and leave their beloved university. The Oglethorpe University alma mater was rewritten in 1987 by Linda Taylor, and it is still in use today.

> Our dear Alma Mater,
> To you we sing our praise.
> Your gray stone and mortar
> Give strength for the coming days.
>
> Then like the Petrel,
> Feet near the ocean,
> We'll rise through wind and rain.
>
> Yes, Oglethorpe,
> You're here to remind us:
> Nescit Cedere.

Four

ACTIVITIES, CLUBS, AND ORGANIZATIONS

Oglethorpe's first newspaper, titled the *Petrel*, was founded on September 25, 1919, by four students. Since the university's athletic teams and mascot are the Stormy Petrels, the group decided to keep a similar name for the publication. The *Petrel* appeared every Friday and was written and published by a small staff of Oglethorpe students. Shown in this 1919 photograph is the first staff of the *Petrel*. (Courtesy of Lane Brothers Collection, Georgia State University Archives.)

The members of the 1920 Alabama Club (top) and Pre-Medical Club (bottom) are shown here. These clubs are two of several short-lived organizations that began in the early years after Oglethorpe's refounding. Besides the Alabama Club, there were other clubs that focused on bringing together students from specific regions and cities, including the Norcross, Locust Grove, South Carolina, and South Georgia Clubs. The Pre-Medical Club was one of two of the first academic organizations on campus. The LeConte Society, which outlasted the Pre-Medical Club, was founded in 1920, and its purpose was to join together students interested in pursuing scientific studies and careers. (Courtesy of Lane Brothers Collection, Georgia State University Archives.)

The Oglethorpe Orchestra was founded in 1918 and made several public appearances in its beginning years. The eight-member orchestra of 1920 is shown here, consisting of a student director along with a pianist, a saxophonist, two violin players, a flutist, a drummer, and a cornet player. In 1920, the orchestra was awarded a $500 gift from the Women's Board of the university to purchase more instruments. (Courtesy of Lane Brothers Collection, Georgia State University Archives.)

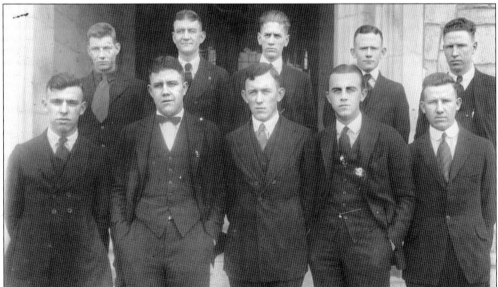

Since 1920, the *Yamacraw* has documented student life at Oglethorpe. The *Yamacraw*, Oglethorpe's annual, was named after the Yamacraw Indian tribe, which lived near Savannah at the time of James Edward Oglethorpe's arrival in Georgia in 1733. The first staff of the yearbook is shown in this *c.* 1920 photograph. (Courtesy of Lane Brothers Collection, Georgia State University Archives.)

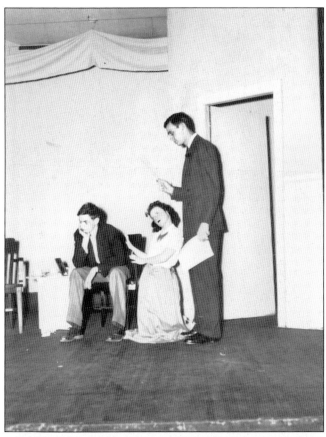

In 1939, when these photographs of an Oglethorpe drama production were taken, the theater program was led by W. Paul Carpenter Jr. Professor Carpenter was appointed before the start of the 1939 school year as associate professor of English. Carpenter graduated from Oglethorpe in 1936 with an A.B. degree, and he earned his M.A. in 1937. Prior to coming to work at Oglethorpe, Carpenter worked as a director of programs at several radio stations and wrote numerous plays and sketches. Carpenter's duties as an Oglethorpe professor included teaching play production and radio play production, in which he emphasized training in voice, radio acting, directing, and writing of scripts.

Students Marjorie Holliday and Jim Holliday are in the middle of being crowned Lord and Lady Oglethorpe on February 9, 1949, in the above image. The 1949 Oglethorpe Ball was held at the Biltmore Hotel in downtown Atlanta. After the coronation, the student body danced to music by Bob Axtell and his orchestra. The event, like all other balls and formals that year, was organized by the seven-member Social Committee. The Oglethorpe Ball was a yearly tradition and was started at the university to honor the founder of Georgia. Lord and Lady Oglethorpe were chosen by popular vote, as is seen in the lower photograph.

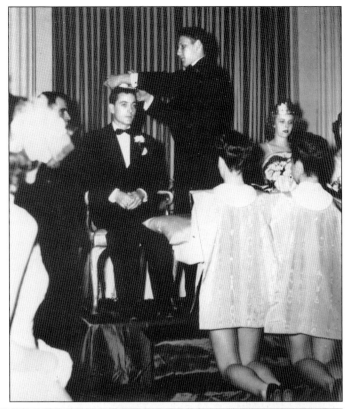

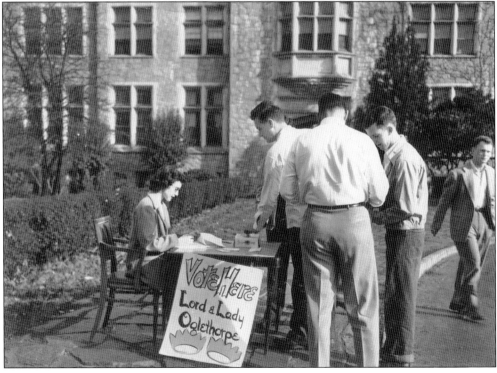

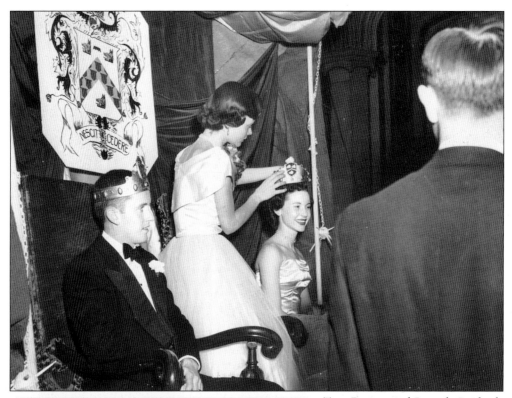

Tom Ronan and Beverly Bechtel were crowned Lord and Lady Oglethorpe by Jane Rand, president of the senior class, in the 1951 coronation celebration (above). The pages of the ceremony (left) carried the two crowns as part of the ceremonial procession. The ceremony was held in the Great Hall of Hearst, and it began with a short talk by Dr. Philip Weltner, president of the university, who welcomed the students, faculty, and guests to the festivities. After the ceremony, refreshments were served in the Oglethorpe art gallery. A highlight of the evening, according to the student newspaper, came when two instructors from the Fred Astaire Dance Studio gave an exhibition of Latin American dances.

The newly crowned Lord and Lady Oglethorpe, Tom Ronan and Beverly Bechtel, look upon their court at the 1951 coronation celebration (above). In the lower photograph, a children's Christmas party that was held in the Great Hall in December 1950 is shown. The celebration was held primarily for children of the faculty and staff, and it included a fully decorated tree and refreshments. During the party, the children made paper crowns, which they decorated with stickers and drawings. Santa Claus, toting a bag of treats, also made a surprise entrance at the celebration to the delight of the children.

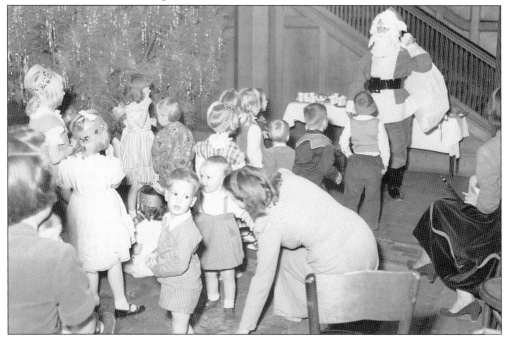

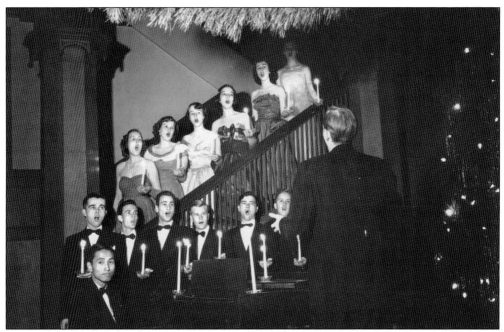

The 1951 annual Boar's Head Ceremony featured the Oglethorpe chorus (pictured above) and orchestra, which together provided a program of Christmas music. In the ceremony, professors also participated by accompanying the group with old English instruments. In the lower photograph, Professors Wendell Brown (left) and George Seward (third from left) can be seen performing with others at the ceremony. The annual Boar's Head Ceremony at Oglethorpe University, a campus tradition that began in 1944, was partly inspired by the coat of arms, which is based on the crest of the family of James Edward Oglethorpe, whose symbol was a wild boar.

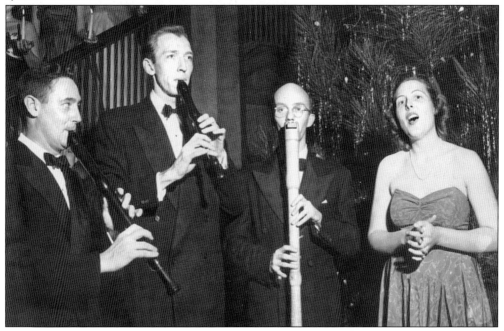

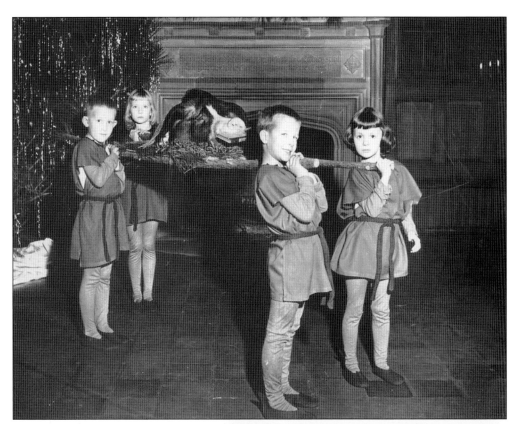

Besides the ties to General Oglethorpe, the Boar's Head Ceremony was also adapted from a traditional celebration at English colleges that marks the beginning of the holiday season. The ceremony was started at Queen's College in Oxford, England, in the 14th century. According to legend, a scholar who was studying Aristotle in the woods was suddenly attacked by a ferocious wild boar. Having no weapon at hand, the student rammed his book down the throat of the boar, choking it to death. That night, the boar's head was brought by procession into the dining room, which began a yearly celebration that has been adopted by several institutions. These 1951 photographs show scenes from that year's ceremony, held in the Great Hall.

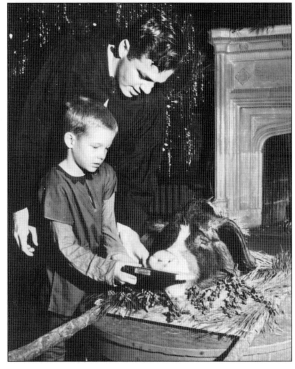

On December 7, 1950, the Oglethorpe Christmas formal was held at Joe Veale's American Legion Post, located in Atlanta. The above and below photographs were taken at the 1950 event, and they capture groups of faculty and students. Dr. George Seward can be seen in the lower photograph on the right, at the end of the table. The music at the formal was provided by Bob Axtell and his orchestra, and students enjoyed dancing and refreshments at the event. According to the student newspaper, the *Stormy Petrel*, the highlight of the evening was the informal presentation of Louise Watkins as the Boar's Head Fraternity Sweetheart.

A couple is shown at right dancing at the 1951 Black and White Formal, held in April. The lower photograph shows an aerial shot of the event, which was held in the gymnasium and featured a live band and candlelit tables. The event was generally sponsored by the freshmen class in the spring. The freshmen class also held an old-fashioned barn dance with square dancing in the spring of that year. The dance, like the Black and White Formal, was held in the gymnasium, which was decorated to look like a barn. The admission price was 35¢ and included refreshments. All Oglethorpe students were invited to attend.

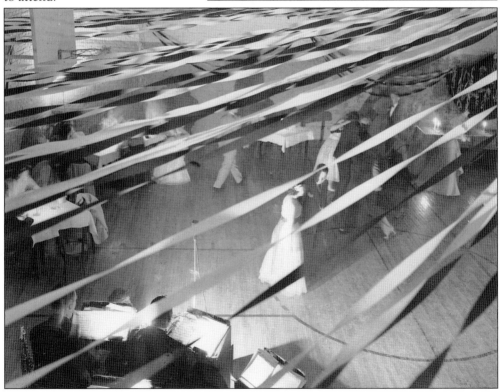

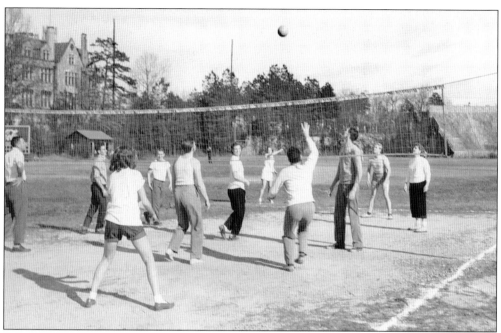

Both volleyball and fencing were played as intramural sports in 1949, when these two photographs were taken. Other intramurals in 1949 included basketball, football, baseball, weight lifting, horseback riding, and boxing. Most of the women and men's intramural sports were kept separate, but both males and females were involved on the same teams in volleyball. Besides the intramural programs, the other student organizations on campus during 1949 included the Blue Key National Honor Fraternity, Boar's Head Honor Fraternity, Duchess Club, LeConte Society, Chapel Committee, Sailing Club, Business Club, Oglethorpe Players, and chorus.

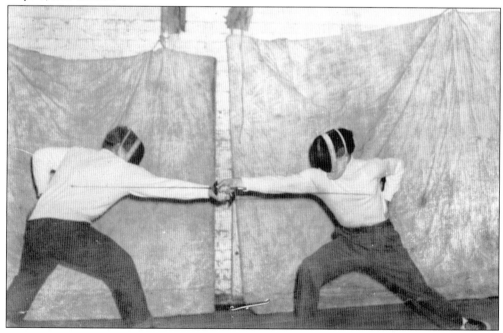

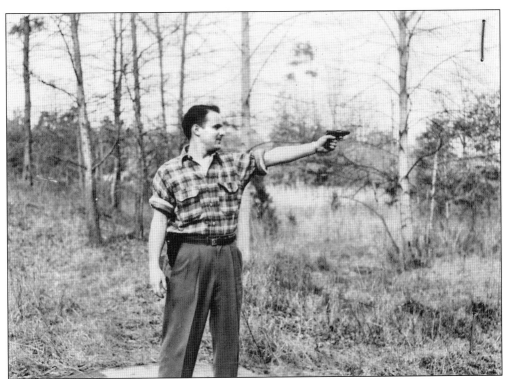

The Oglethorpe Gun Club was organized in May 1948, and according to its description in the student yearbook, it was "dedicated to the furtherment of friendship and understanding among students." The club constructed a firing range on campus, and they met weekly to discuss business matters and to practice. This photograph shows one of the eight members of the 1949 club.

In 1949, when this photograph was taken, there were 12 athletic activities for female students to choose from, including golf, swimming, horseback riding, softball, tumbling, volleyball, tennis, horseshoes, Ping-Pong, basketball, badminton, hiking, and archery. The women's athletics programs were mostly on an intramural level, except for the basketball, softball, and tennis teams, which participated in intercollegiate competitions.

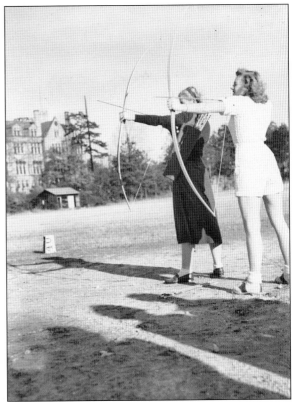

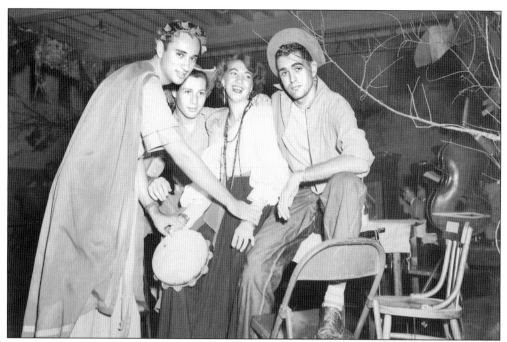

Two events from the fall of 1950 are shown here. The annual Masquerade Ball (above) was held in October, and students who attended were to dress in costume. The Sadie Hawkins dance (below) was held in November, and it was organized by the Duchess Club. The Duchess Club also held a comical wedding play on the same day. The fall of 1950 saw several other student celebrations, one of which was the Boar's Head Fat-Man Thin-Man basketball game on November 16. All participants and attendees were charged a 25¢ admission fee and were encouraged to dress in burlesque fashion, as it was the theme for the game.

In the above 1961 image, three members of the Oglethorpe Players performing in *My 3 Angels* are shown. The play was the first production of the season, and it was a story of three very un-angelic convicts who cause problems for a store owner's family. Sam Braswell (left), Bob Strom (center), and Ben Matthews played the three devilish angels in the production and are shown here releasing a pet snake in a performance. Below, a member of the 1967 Players performs in one of the fall plays. During the fall season, the Players performed two medieval plays including *Everyman*, a morality play, and *Johan*, a comedy that amused audiences with slapstick humor.

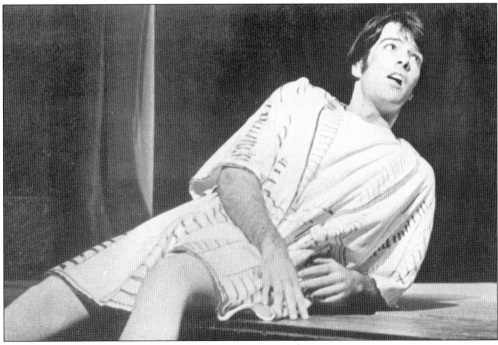

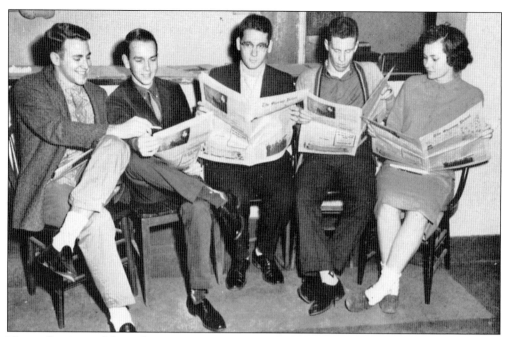

The staff writers of the 1961 *Stormy Petrel* are shown here. The *Stormy Petrel* group described themselves in the yearbook as a publication that "seeks to report and interpret campus and non-campus news and provide an outlet for expression for both faculty and students." The group also stated that they expressed "a liberal outlook on life, constantly striving to stimulate thought on campus."

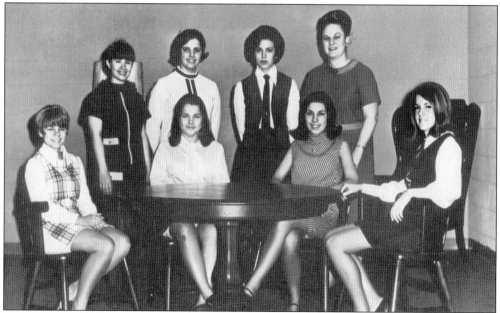

The 1969 Duchess Club can be seen in this image. The Duchess Club was an honorary society for junior and senior women who maintained an excellent academic record and were active participants in campus affairs. The club originally began in 1920 with the ideal of providing service on the campus, and it lasted as a campus organization until the mid-1970s.

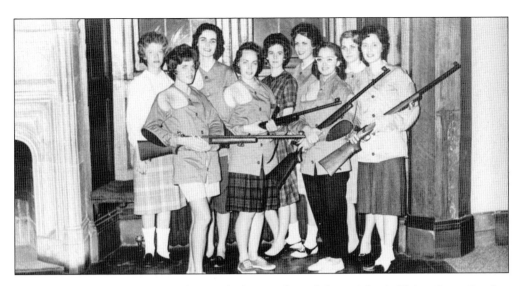

The 1962 rifle team is shown above. The group, from left to right, is Vivian Gray, Carolyn Stemples, Joyce Gravel, Patsy Turner, Cherry Hodges, Jane Lee Conner, Diane Leonard, Bambi Klein, and Virginia Bremer. The group was led by captain Joyce Gravel, who was later inducted into the Oglethorpe University Athletic Hall of Fame. During 1962, there was also a pistol team, which was an all-male team. The lower photograph captures the 1962 student pep band at a basketball game. The group called themselves the Saints and included Frankie Mahaffrey, George Alexander, Terry Ingerson, Lynn Drury, Bill Hagan, Ed Moore, Chip Mobley, Jack Warren, and Cabot Gupton.

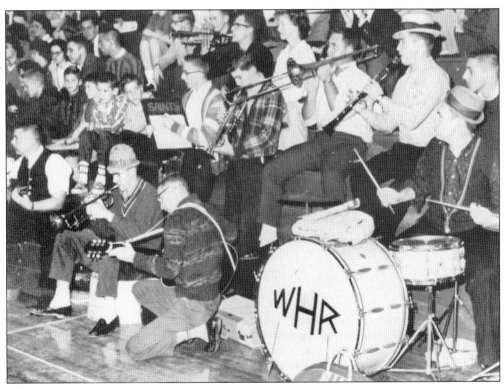

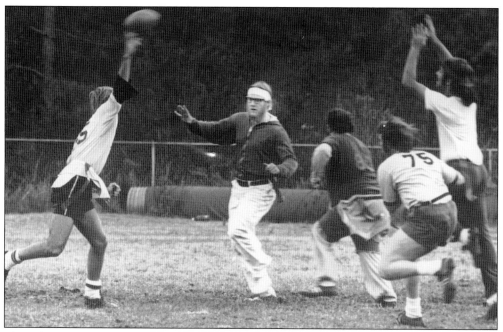

Though the official Oglethorpe competitive football team was suspended during the 1940s, intramural football has been a popular athletic pastime and leisure activity among students. This image, *c.* 1972–1973, shows an intramural football game. Competitive football games between fraternities were also played at the time of this photograph.

Members of the Oglethorpe Recorder Ensemble and the University Singers are seen entertaining the crowd in the concert portion of the 1988 Boar's Head Ceremony, which was held in Lupton Auditorium. Omicron Delta Kappa, a national leadership honor society that was founded at Oglethorpe on April 2, 1976, began sponsoring the ceremony in 1977.

Five

ATHLETICS

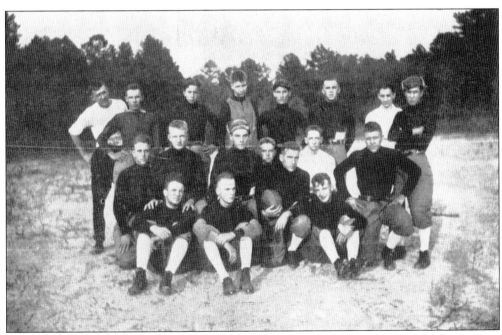

The first Oglethorpe University football team, pictured here, was founded in early October 1917 by coach Frank B. Anderson. It was already late in the season to start practice, and with only about 70 males enrolled in the school, the possibility of a competitive football team did not look promising. About 20 students offered their support, however, and after two weeks of practice, the team competed in their first game.

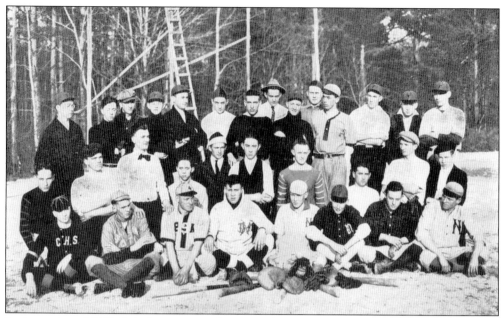

In the spring of 1917, Oglethorpe started practice for the first baseball team of the university. The baseball aspirants from which the first varsity team was chosen are pictured above. During its first season, the baseball team played six games, and though the team did not win even one game, according to the yearbook, they "did put up a creditable showing." Frank Anderson was appointed as the coach late in the season. The first track squad of the university is shown below, c. 1919. From left to right are Meredith de Jarnette, Cecil Lemon, R. G. Nicholes, H. L. Cooper, and E. E. Moore. The team competed in a track meet in 1919 at Georgia Tech, and captain Meredith de Jarnette won the 100-yard dash.

The three leaders of the 1926 football team are photographed here. The coaches are, from left to right, Kenneth "Nutty" Campbell (assistant coach), Harry Robertson (head coach), and Harold Chestnut (freshmen coach). Nutty Campbell was himself a football player and a 1927 graduate of Oglethorpe. Both Campbell and Robertson were inducted into the Oglethorpe University Athletic Hall of Fame in the 1960s.

The freshmen basketball team of 1926 had a highly successful season, losing only one game. The Petrels defeated such notable opponents as Georgia Tech, Mercer University, and the University of Georgia. The 1926 team was coached by George W. "Caruso" Hardin (top right), who was a 1927 Oglethorpe graduate and football star of the university.

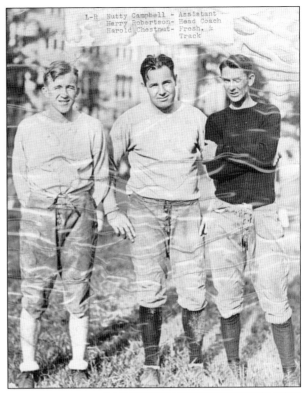

L-R Nutty Campbell - Assistant
Harry Robertson- Head Coach
Harold Chestnut- Fresh. &
Track

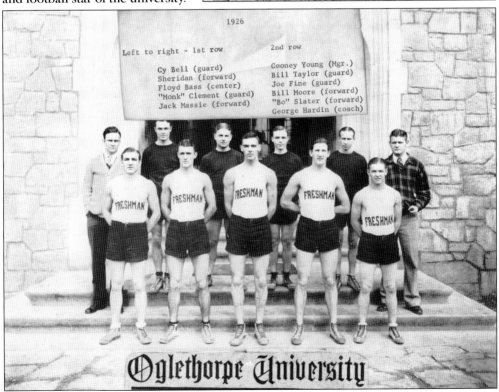

1926

Left to right - 1st row

Cy Bell (guard)
Sheridan (forward)
Floyd Bass (center)
"Monk" Clement (guard)
Jack Massie (forward)

2nd row

Cooney Young (Mgr.)
Bill Taylor (guard)
Joe Fine (guard)
Bill Moore (forward)
"Bo" Slater (forward)
George Hardin (coach)

Oglethorpe University

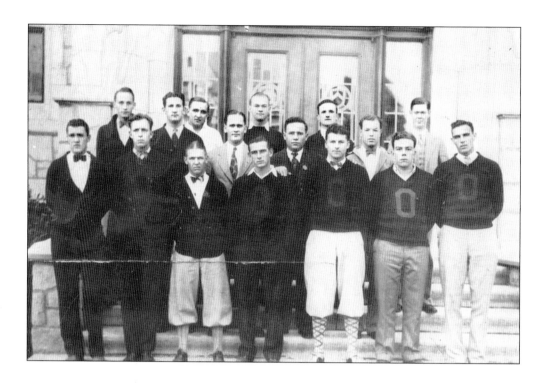

The "O" Club of 1927 is photographed above. The "O" Club was officially founded on February 6, 1920, by coach Frank B. Anderson and several of the student athletes. The club was composed only of males who had earned varsity letters in athletics. According to its mission statement published in the *Yamacraw*, the object of the club was "to aid in uplifting the ideals and standards in college athletics." In the early 1940s, the club began organizing the fall Homecoming Dance, which became the biggest university event of the season. Pictured below in 1927 are the Oglethorpe varsity football ends. The ends, from left to right, are Heywood "Monk" Clement, Roy Hancock, ? Darnell, and Jeff Burforf.

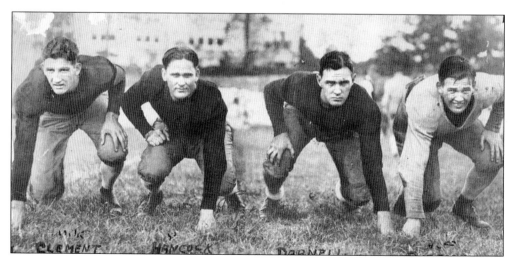

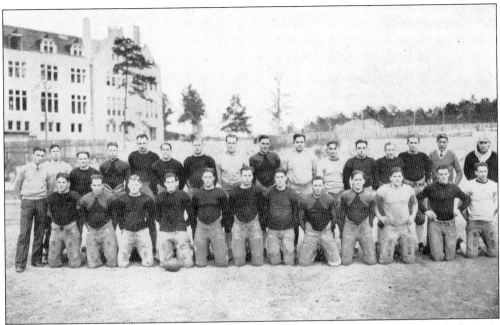

Pres. Thornwell Jacobs was determined to gain attention and notoriety for Oglethorpe's burgeoning athletics department, and in 1925, he added coach Harry Robinson, an All-American from New York, as the football coach for the university. In 1924 and 1925, the football team won the SIAA championship, and the 1925 winning team is pictured above.

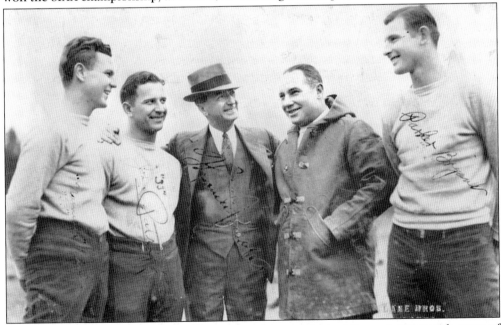

This 1933 autographed photograph captures the president of the university with some of the important athletic figures of that year. From left to right are unidentified, John Patrick, Pres. Thornwell Jacobs, coach Harry Robertson, and Parker Bryant. Patrick would take over the football team from his coach, Harry Robertson, the year this photograph was taken. (Courtesy of Lane Brothers Collection, Georgia State University Archives.)

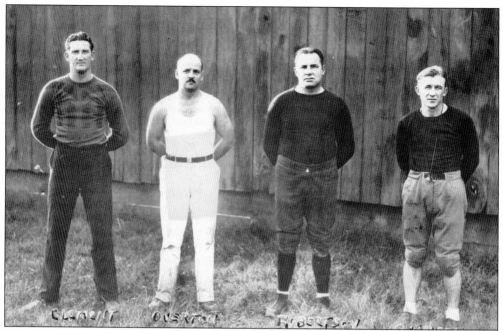

Pictured above is the Oglethorpe coaching staff of 1930, which included, from left to right, Heywood "Monk" Clement, football trainer and graduate of 1930; Don Overton, basketball coach; Harry Robertson, head football coach; and Kenneth "Nutty" Campbell, assistant football coach. Photographed below is the Oglethorpe varsity basketball team of 1930, which unfortunately, according to the *Yamacraw* yearbook, "experienced the worst season in the history of Oglethorpe basketball teams." The team lost every game of the season, but the yearbook noted that all those who witnessed the games could "appreciate the effort put forth by the team, which on several occasions, was only beaten by a one point margin."

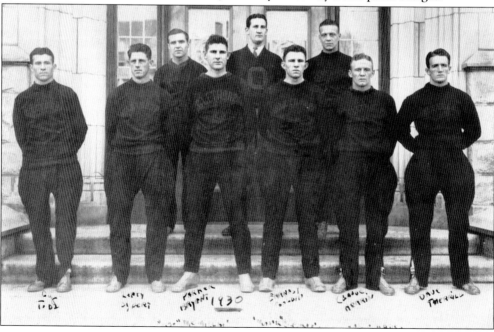

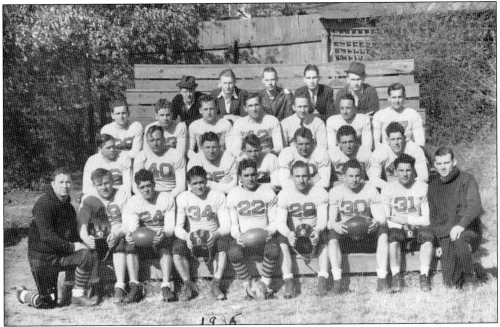

The varsity football team of 1936 is shown in the above image. The varsity team was headed by John Patrick. That year, the varsity team played against Mercer University, Erskine College, Mississippi State, and others. The freshmen team of 1936, which is photographed below, was also led by Patrick, and there were several notable athletes who started their Oglethorpe athletic careers on the team. Pictured here, from left to right, are (first row) Phil Hubbard, Howard Axelberg, Patrick, Bo Denning, and Steve Schmidt; (second row) Pop Barnett, Bobby Mills, Martin Kelly, Arvil Axelberg, and Trigger Thomason; (third row) Fred Kelley, Marvin Chesser, and Andy Yokovich.

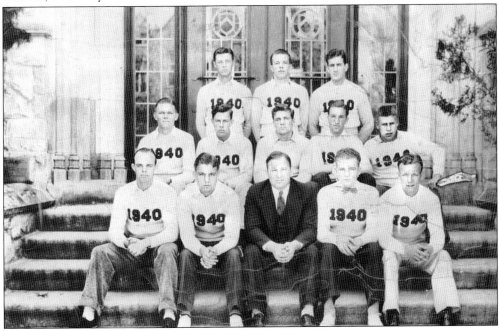

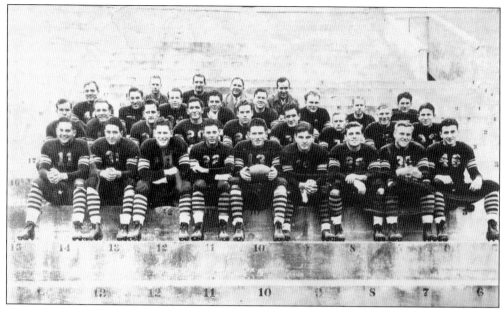

The 1937 varsity football team, photographed above, played against several tough competitors. Their first game was against the University of Georgia and was held in Athens, Georgia, and their last game was against the Citadel team, which was also an away game. The 1936 and 1937 years were difficult years for the Petrels. In 1936, according to the *Yamacraw*, there was an "injury jinx" in Hermance Stadium, and many of the players had to play throughout the season without substitution because of the lack of uninjured players. The year 1937 was a challenging year as well because the team lost eight of its graduating seniors. According to the yearbook, the "stormy petrels, true to their namesake, flew perpetually against advance winds, facing reputable opponents, and constantly displayed heroic courage despite great handicaps." The lower photograph was taken during a game, *c.* 1939.

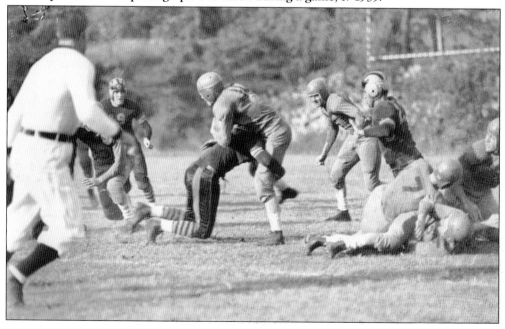

The varsity football team of 1939 was coached by John Patrick. The football team, pictured above and below in Hermance Stadium, produced several notable athletes and Oglethorpe University Athletic Hall of Fame members. The members of the class of 1940 on this team who received recognition in the hall of fame include Howard G. Axelberg, W. Elmer George, Homer Fred Kelley, and Stephen J. Schmidt. George L. Hooks, Ernest O. "E. O." Sheffield, and Anthony S. Zelencik, class of 1941, also played on the team and were awarded places in the hall of fame.

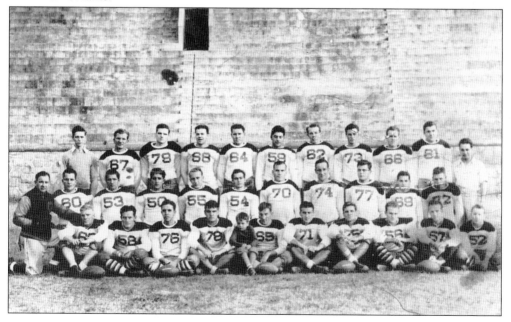

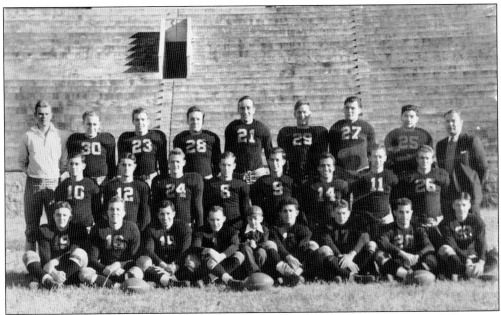

The 1940–1941 football team is captured in the above photograph in Hermance Stadium. This team would be one of the last football teams at the university; World War II curtailed all sports in 1942, and after the war, though there was an attempt to reform the football program, it was not truly successful. Below, the baseball team of 1939 is pictured, along with coach Frank B. Anderson (upper left). Anderson, under Pres. Thornwell Jacobs, founded the athletics program of the university, and he coached the baseball teams for many years. Anderson developed several great players who reached Major League Baseball teams, including Luke Appling (class of 1932), Lucas Turk (1920), Clay Parrish (1926), Charles "Greek" George (1934), and Leonard "Lefty" Willis (1925).

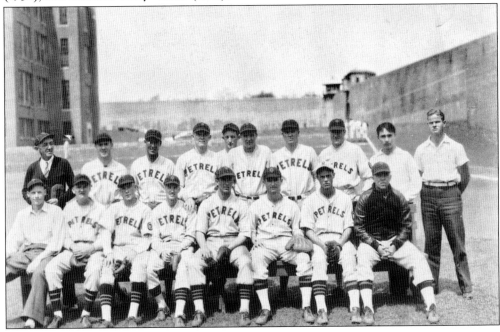

A 1949 Oglethorpe basketball game is shown above, and Oglethorpe basketball fans are captured below. During the 1948–1949 season, the "Petrel Hoopsters" were led by student-coach A. Z. Johnson (class of 1950), who was inducted into the Oglethorpe University Athletic Hall of Fame in 1977. The Petrels played against several large institutions, many of which had six times as many male students as Oglethorpe, including such schools as Florida State, Howard, and Mercer Universities. Some of the outstanding players from this team who were inducted into the Oglethorpe Hall of Fame include James H. Hinson and Robert J. Findley, both from the class of 1949.

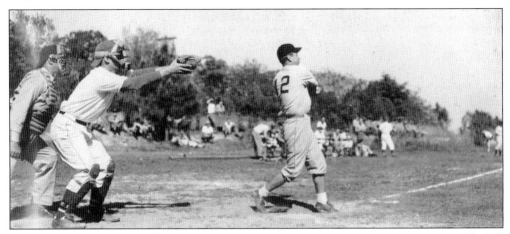

The Stormy Petrels baseball team of 1948 was quite successful, winning 17 games and losing only 3. They also enjoyed a winning streak that lasted for an amazing 14 consecutive games. The team was led by coach Don Brennan, who also played as second baseman. This 1948 photograph shows an Oglethorpe team member at bat.

The 1951–1952 cheerleaders are shown in this photograph, which was taken for the 1952 *Yamacraw* yearbook. The squad was headed by captain O. K. Sheffield, shown in the middle, and tryouts were held on November 9, 1951. The final group was chosen after three weeks of daily practice. The cheerleaders appeared at all basketball games and were the unofficial hosts to visiting teams during the tennis season.

In 1956, coach Garland Pinholster arrived at Oglethorpe. With no athletic budget and very few athletes, Pinholster organized the first Booster Club to build support for the program. Within a few years, the basketball team was again competing in national tournaments, and by 1961, they were defeating strong teams in the district National Association of Intercollegiate Athletics (NAIA) playoffs. The 1961–1962 team is shown in the above photograph, and it included several notable hall of fame members, such as John Guthrie, Tommy Norwood, Ray Thomas, Bobby Nance, Bob Sexton, Morris Mitchell, Darrell Whitford, and Jay Rowland. The 1964–1965 basketball team, also coached by Pinholster, is shown below. During his time at Oglethorpe, Pinholster compiled a record of 184 against only 62 losses. Garland Pinholster was among the first group inducted into the Oglethorpe University Athletic Hall of Fame, and he also authored five books.

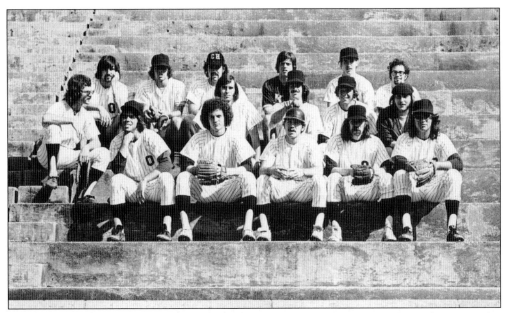

The baseball team of 1972–1973 is photographed in Hermance Stadium (above), and a basketball game played at Oglethorpe during 1973 is photographed below. The members of the 1972–1973 basketball team who were inducted in the Oglethorpe Athletics Hall of Fame include William Sheats and Randall Lee. Though these photographs document competitive sports, during the early 1970s, the intramural sports were also quite popular. Greek organizations, including Chi Phi and Kappa Alpha, would play other Greek teams, and they would also compete against non-Greek teams, such as the Sigma Alpha Mu (SAM) team. There were basketball, football, and soccer intramurals during the time these images were taken.

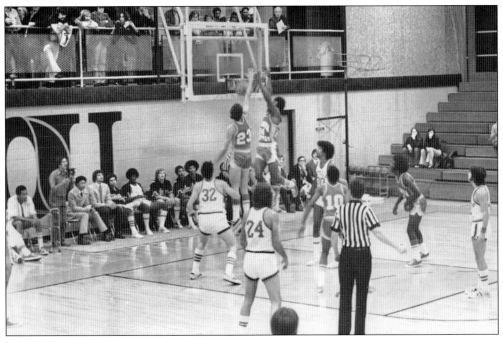

The 1961–1962 Oglethorpe varsity cheerleaders included, from left to right, Jane Lincoln, Paula Coker, Jacque Cook, Jackie Murphy, Donna Williams, Adgate Gay, and Sandy Wolsey. The basketball team won 20 out of 24 games that year against such teams as Georgia Southern, Rhode Island, and Mississippi Southern. There was also a B-team cheerleading squad that year, which cheered at the B-team basketball games.

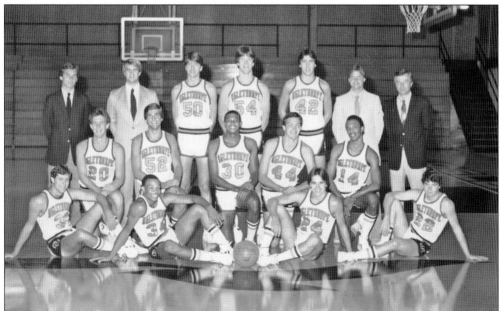

The basketball team of 1982–1983, coached by Jack Berkshire (third row, right), is shown above. The team had three Academic All-Americans in basketball: Jay VanderHorst (first row, left), John Marshall (first row, third from left), and Steve Oliphant (second row, second from right). It was the first time three players on the same team were so honored. Jay VanderHorst and Steve Oliphant later became part of the Oglethorpe University Athletic Hall of Fame.

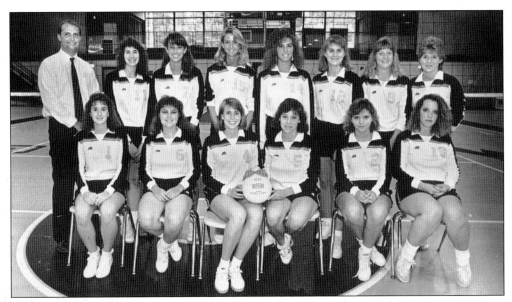

Pres. Manning Pattillo had the goal of developing a broad-based athletics program to compete against small liberal arts colleges with strong academics. During his time as president, he hired Jack Berkshire as director of athletics and the men's basketball coach. In 1988, Oglethorpe's athletics program joined the National Collegiate Athletic Association (NCAA) at the Division III level, and in 1991, the university became a member of the Southern Collegiate Athletic Conference (SCAC). Under Berkshire's leadership, the athletics program increased from 6 sports to 14, and 7 were women's sports. The 1989 women's volleyball team is photographed above. The basketball program was also extremely successful under Berkshire. The men's basketball team won the university's first SCAC championship in 1994, with the winning team shown below. The 1994 team earned a spot in the NCAA national playoffs, as did the 1995 team, which finished second in the conference race.

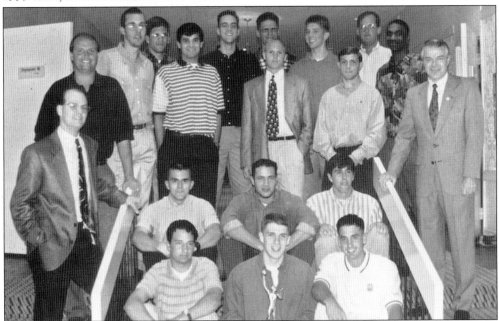

Six

FAMOUS MOMENTS
AND EVENTS

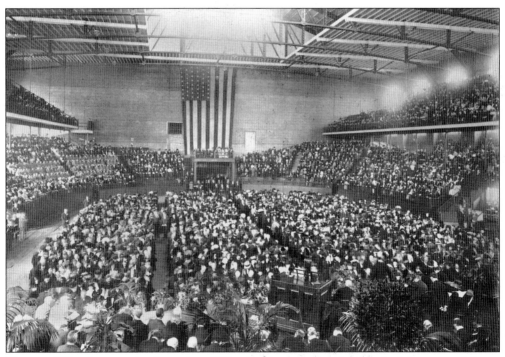

Thornwell Jacobs organized a series of "Pan Presbyterian" gatherings in Atlanta to celebrate the 50th anniversary of the Southern Presbyterian Church and to stir up interest in his plan to reestablish Oglethorpe University. One such gathering is illustrated in this 1910 photograph of a Presbyterian Jubilee. Rev. James Isaac Vance of Nashville, Tennessee, gave the keynote address. (Photograph by T. B. Mathewson, Atlanta.)

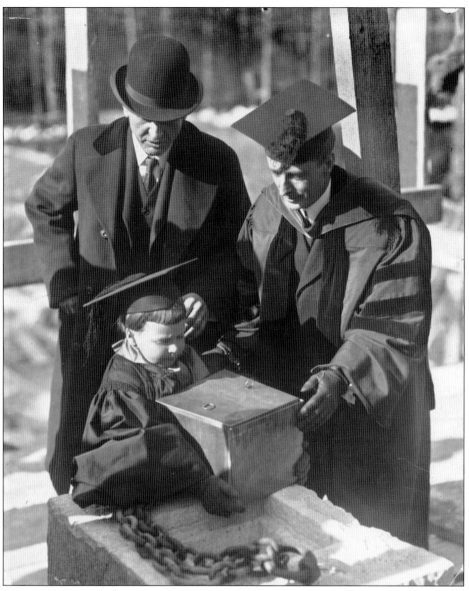

On January 21, 1915, at 10:00 a.m., the cornerstone-laying ceremony for Oglethorpe University in Atlanta began at North Avenue Presbyterian Church. Eight alumni of the original campus attended the services. They included J. R. Varnedoe, Rev. W. T. Hollingsworth, B. L. Gaillard, A. C. Briscoe, Clinton Gaskill, Rev. E. M. Green, William L. LeConte, and B. T. Hunter. The official cornerstone laying took place on the site of the new Oglethorpe campus that afternoon. The event was covered in the *Westminster Magazine* of February 1915, which identifies those in the above picture. Little Frank Inman Jr. places the copper box in the cornerstone of the first building. William H. George, the superintendent of construction work, stands behind him. Dr. Thornwell Jacobs, on the right, was appointed president of the university on January 21 and officially accepted on April 8. Frank was the son of the chairman of the Grounds Committee and grandson of the late Sam Inman. Like its predecessor in Midway, which is located near Milledgeville, once the capital of Georgia, the new campus was again located close to the capital city of Atlanta.

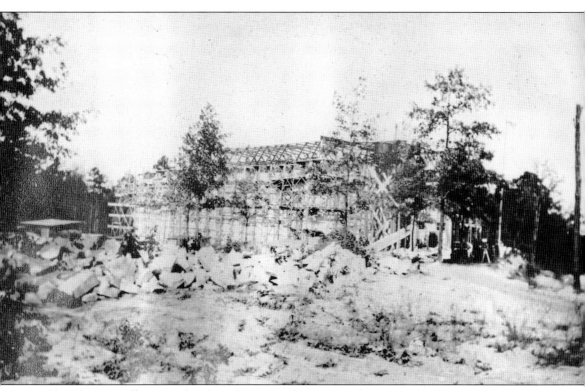

Like Thomas Jefferson, who thought that architecture influences people, Pres. Thornwell Jacobs believed the buildings of the Oglethorpe campus in Atlanta were there to delight and inspire the students. He referred to them as "the silent faculty" of the university. Jacobs's master design for the campus included buildings and landscaping that would promote the feel of the European institutions of higher learning, such as Oxford and Cambridge. The first building to be constructed on the Atlanta campus was the administration building, later renamed Phoebe Hearst Hall in honor of the mother of Oglethorpe benefactor William Randolph Hearst. Built in 1915 by the Atlanta firm of Morgan, Dillon, and Downing, this signature building of Oglethorpe University started the campus, which stands today as one of the most architecturally alluring universities in the city. Limestone from Indiana and blue granite from Elberton, Georgia, were used to construct the striking buildings.

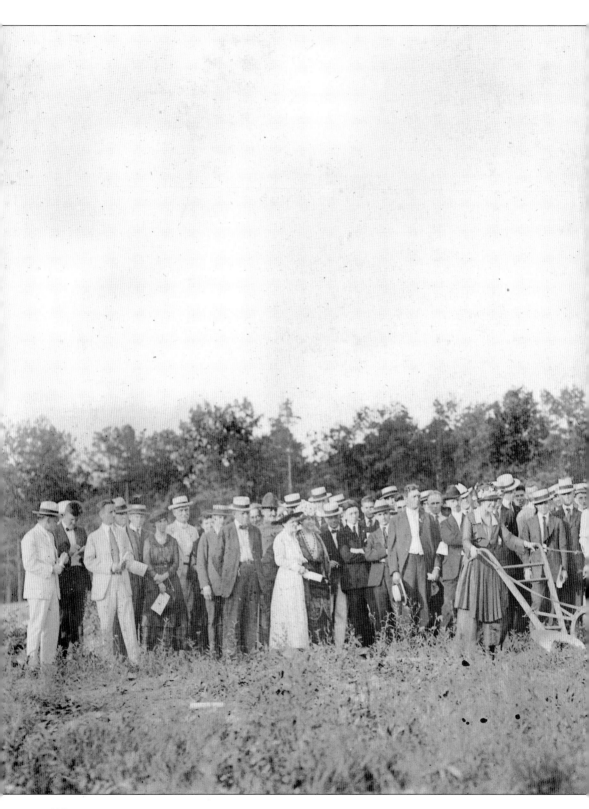

Around the early 20th century, mules were still used to move and drag earth and stone during major construction work, including all grading. Here the Oglethorpe University librarian is seen behind the plow assisting in the effort as ground is broken on June 11, 1919, for the second building, which became Lupton Hall. Thanks to the generosity of John Thomas Lupton of Chattanooga, Atlanta banker Robert J. Lowry, Harry Hermance, and William Randolph Hearst, the major quadrangle buildings were completed over a period of several decades. Additional funds were given by Lupton to keep the buildings maintained. Hearst provided the money to buy acreage for the campus, including the Silver Lake area.

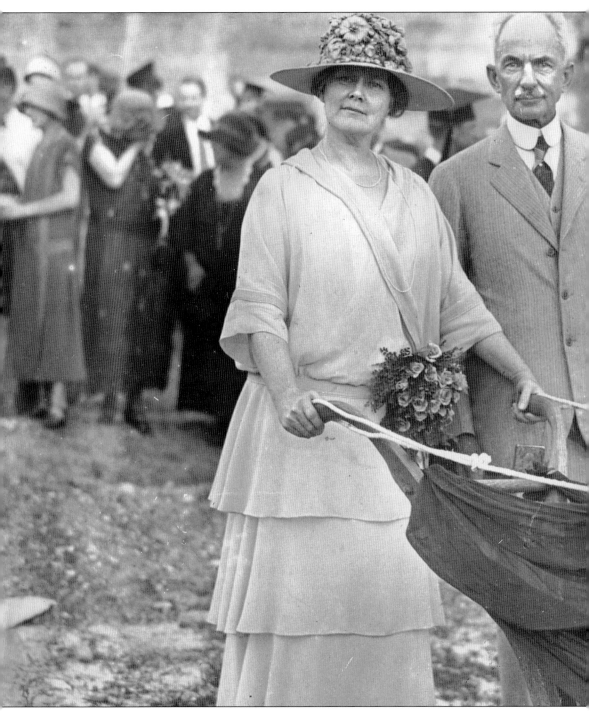

John Thomas Lupton and his wife, Elizabeth Olive Patten, of Chattanooga, Tennessee, are seen with Thornwell Jacobs (right) at the 1927 ground-breaking ceremony for Lupton Hall, one of the outstanding buildings on campus. The Atlanta papers described the dedication ceremony as "an event of social brilliance, significant at the same time in the educational life of the south." The inspiring Gothic structure was composed of two separate buildings

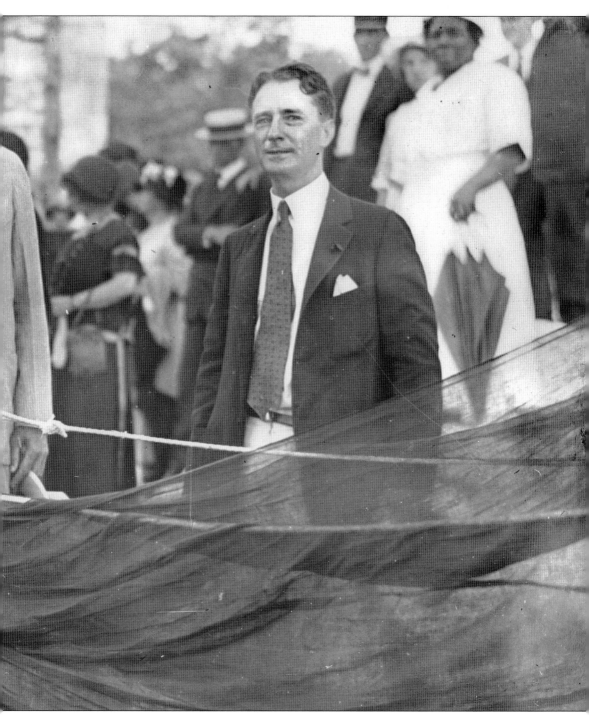

connected by a third and built between 1920 and 1927. Jacobs and Lupton met at a Presbyterian church in Tennessee when Jacobs came to deliver a fund-raising speech. Lupton became one of the most munificent donors to the campus. He also gave the funds for the radio station on campus, WJTL, named in his honor. Lupton and Thornwell Jacobs remained close friends until Lupton's death in 1933.

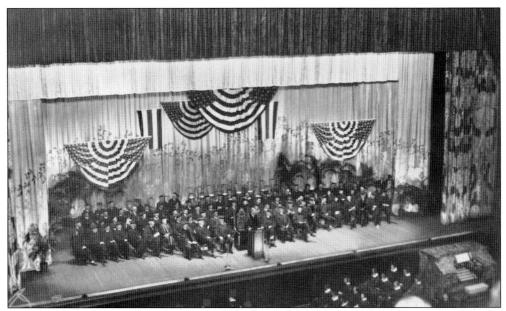

On May 23, 1932, the governor of New York and future president, Franklin D. Roosevelt, was awarded an honorary doctor of laws degree and also delivered the commencement address for Oglethorpe University. The above image shows the commencement group on stage at the Fox Theater in Atlanta, where the event was held. Pictured below, backstage at the ceremony, are, from left to right, Thornwell Jacobs, Franklin D. Roosevelt, Georgia governor Richard B. Russell Jr., and Barron Collier. Roosevelt's commencement address reflected the New Deal principles he would later deliver to the nation as president of the United States. (Courtesy of the *Atlanta Journal Constitution*.)

Pictured in the above photograph, taken backstage at Roosevelt's commencement address, are, from left to right, Thornwell Jacobs, Atlanta mayor James Key, Roosevelt, Gov. Richard Russell, Barron Collier, and Oglethorpe board members Edgar Watkins and Col. Hollins Randolph. Judge Edgar Watkins can also be seen in the lower image, straightening Roosevelt's robes. Judge Watkins served as chairman of the board of trustees at Oglethorpe and was a staunch supporter of the university for more than 30 years. He was instrumental in bringing Philip Weltner to the campus, in addition to supporting and maintaining the university during some of its most challenging times. (Courtesy of the *Atlanta Journal Constitution*.)

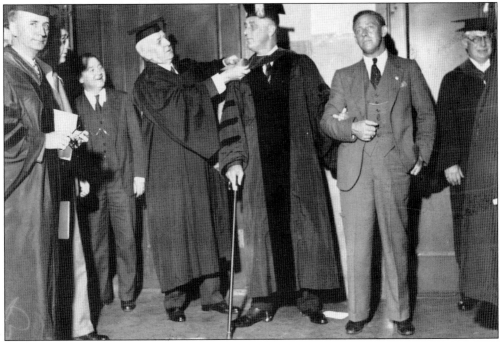

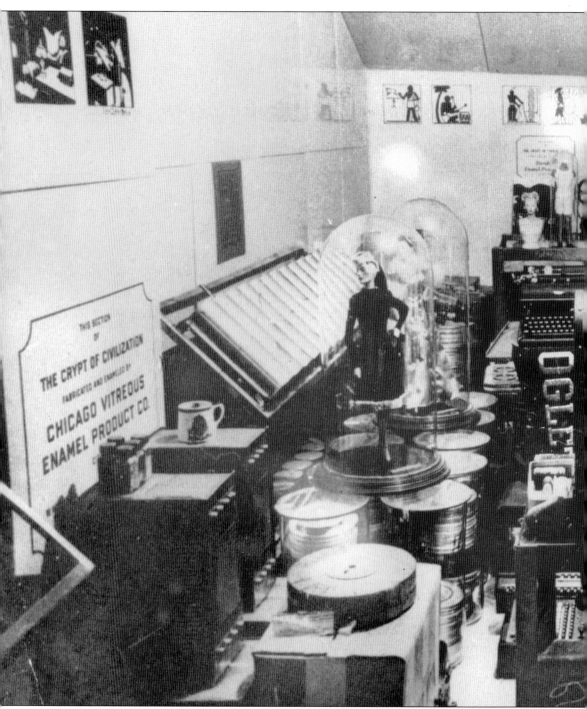

The Crypt of Civilization, the brainchild of Thornwell Jacobs, was created to collect and preserve facts and objects of western civilization. Jacobs conceived of the idea in 1937 and hired T. K. Peters as archivist for the project. Peters organized and collected the materials for the 20-by-10-by-10-foot vault and arranged for student assistants to microfilm more than 960,000 printed pages. This photograph provides a rare glimpse of what lies within the

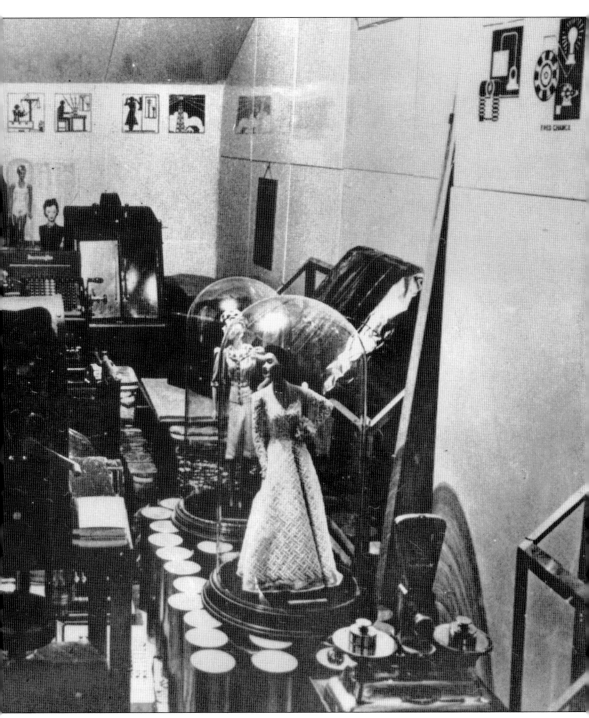

crypt, which was sealed in the basement of Hearst Hall during an elaborate ceremony on May 25, 1940. It is not to be opened until 8113 AD. The date was chosen by Jacobs because the first known date in recorded history, 4241 BC, was 6,177 years previous. Jacobs suggested that the Crypt be sealed until 6,177 years had passed, which set the date for the reopening in the year 8113.

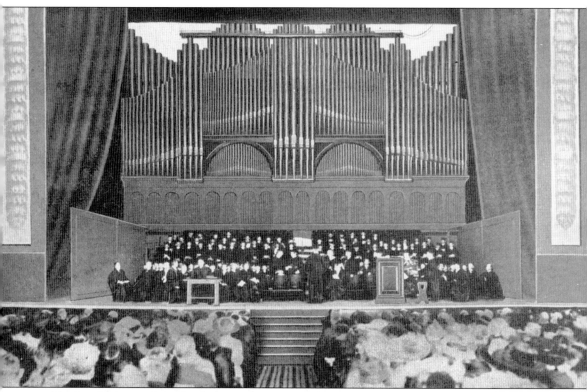

The first freshman class of Oglethorpe University is shown singing "Fair Alma Mater, Oglethorpe" at the great Presbyterian jubilee in the Atlanta Auditorium in this 1916 image. The jubilee was held on September 24 in Atlanta and was a gathering of all the Presbyterian churches in the city. The image appeared in the 1917 Oglethorpe University *Bulletin*, which included information on the history of the school, courses, professors, and campus life. The school opened its doors on September 20, 1916, four years after the cornerstone was laid with the engraving, "Manu Dei Resurrexit," meaning, "By the hand of God she has risen from the dead." The first freshmen class of the university gathered at the Presbyterian Jubilee to celebrate the past connections between Oglethorpe University and the Presbyterian churches and to thank the many churches who donated money to the cause of refounding the university.

A child star in the 1910s, Madge Evans (1909–1981) enjoyed a successful acting career, even playing the first *Heidi* in 1920. MGM signed her, and she appeared in their films, including *Pennies from Heaven, David Copperfield*, and *Sporting Blood*. Her performance in *Lovers Courageous* inspired Pres. Thornwell Jacobs to write *Not Knowing Whether He Went*. Evans is pictured holding a copy of the book, which was also dedicated to her.

During a visit of the Ringling Brothers and Barnum and Bailey Circus to Atlanta in 1941, several elephants were mysteriously poisoned. Oglethorpe's Dr. John Barnard arranged for the carcass of one of the pygmy elephants to be brought to campus for the medical students to study and dissect. After the dissection was completed, a grave was dug behind Lowry Hall. Students are seen gathering around and standing atop the elephant in the above image.

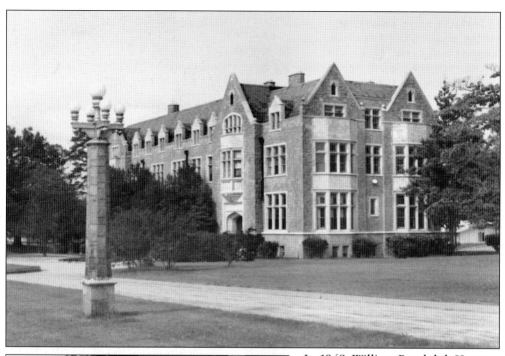

In 1948, William Randolph Hearst gave the university $100,000, and subsequently, Pres. Philip Weltner named the administration building in honor of Hearst's mother, Phoebe. Hearst had also given $5,000 for the founding of Oglethorpe during the original campaign of Thornwell Jacobs in 1913. A few years later, Jacobs flew to California and met Hearst at San Simeon to ask for help in securing the property next to the campus that was for sale. Hearst gave the funds to purchase the 600 acres surrounding and including Silver Lake. In 1927, Hearst was awarded an honorary doctor of laws degree by the university. The impressive Hearst Hall, photographed above, includes the elaborate Great Hall area, which was used in 1989–1990 to film the Hallmark Hall of Fame television production *Caroline?*, starring Patricia Neal and Stephanie Zimbalist, who is shown below during filming in the hall.

In 1925, the ground breaking for Oglethorpe's third signature building took place. Built in the Gothic style, the elegant structure copied the architectural design of Corpus Christi College, Oxford, the alma mater of James Edward Oglethorpe. Funds were provided from the estate of Atlanta banker Robert J. Lowry, who served as president of the American Bankers Association.

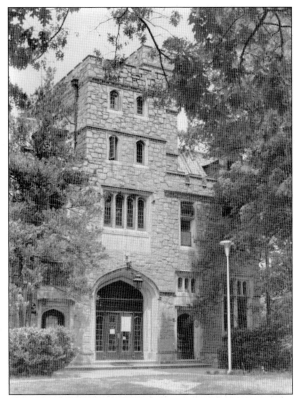

On November 12, 1968, the Mills B. Lane Jr. Music Room was dedicated. In this photograph, Mills B. Lane Jr. (left), President Beall (center), and professor of music Harry Dobson share in the ceremonies. The room was named in honor of Lane, president of C and S Bank and board member of the university. Contributions for the renovation of the room were made by Betsy Prim (1965) and William Trapnell.

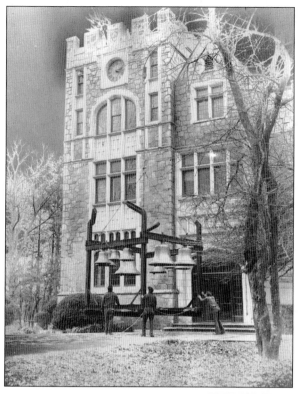

In 1972, the oak timber frame supporting the bells in the clock tower of Lupton Hall was discovered to be rapidly deteriorating. Plans were made to correct the situation, and the bells were removed and sent to I. T. Verdin in Cincinnati, Ohio, for restoration and sounding. The removal of the bells was overseen by Graham Spickard. He also supervised the construction of the new steel frame and the installation of the bells. In January 1972, a huge crane was used to remove and lower the bells onto a truck for the trip to Cincinnati. The truck and crane returned to campus in December to install the bells, along with seven additional Petit and Fritzen bells. The 42-bell carillon is the only cast-bronze carillon in Georgia.

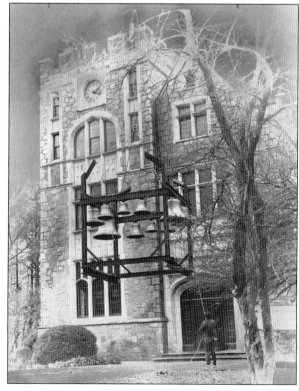

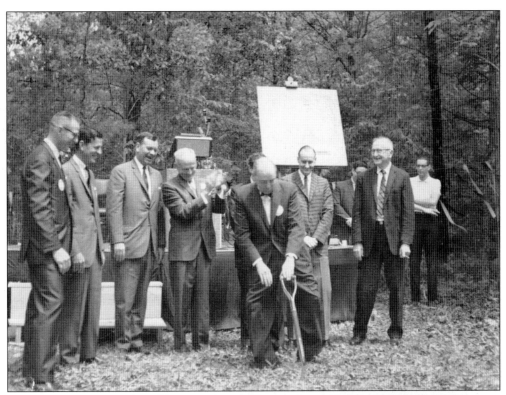

On Alumni Day, May 14, 1966, ground breaking for the new $2 million campus-wide building project, including the Student Union building, was held. Sen. Herman Talmadge presided along with chairman of the board Robert L. Foreman, who wields the shovel in the above photograph. In attendance were, from left to right, Garland F. Pinholster, vice president for development; Frank Sheetz of Sheetz and Bradfield architecture firm; Herman Talmadge; Pres. Paul R. Beall (also seen in the photograph below); Robert L. Foreman; James E. Findlay, vice president for business affairs; and former president Philip Weltner. The Student Union building, later named for trustee William Emerson, incorporated a French provincial theme with a modern interior. The funds were also used for a number of projects, including improvements to Hearst, Lupton, and Lowry Halls. (At right, photograph by Stietenroth, Atlanta.)

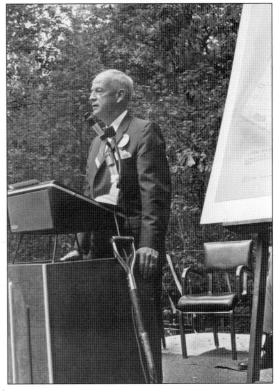

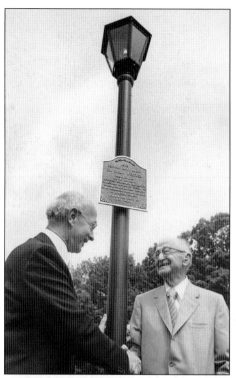

President of Oglethorpe University Paul Kenneth Vonk (left) shakes the hand of Philip Weltner (right), recipient of the 1973 Shining Light Award. The award, sponsored by WSB Radio and Atlanta Gas Light Company, was given annually to a Georgia citizen whose work served as inspiration. Weltner's life accomplishments included his role as secretary of the Georgia Prison Association, chancellor of the University System in Georgia, and president of Oglethorpe University.

Governor of Georgia Jimmy Carter is seen handing an official proclamation to Oglethorpe president Paul Kenneth Vonk. The proclamation declares February 1972 as Independent Higher Education Month in Georgia. Vonk, president of the Association of Private Colleges and Universities in Georgia, accepted the award, which paid tribute to the state's private educational institutions. Vonk was president of Oglethorpe University from 1967 to 1975. (Courtesy of Lane Brothers Collection, Georgia State University Archives.)

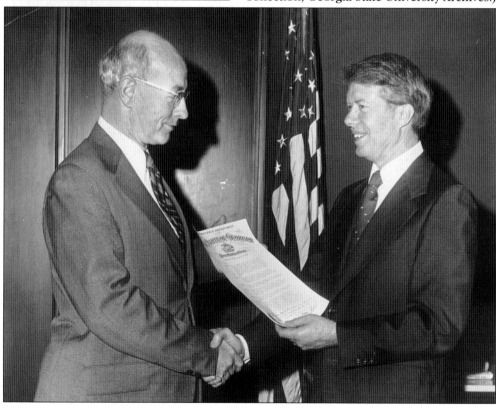

On April 29, 1977, Griffin Bell was keynote speaker at Law Day and Convocation. Acting in accordance with a resolution passed by Congress that May 1 would be set aside annually as Law Day, Oglethorpe University celebrated by hosting Bell, the 77nd attorney general of the United States under Pres. Jimmy Carter. The Joint Resolution for Law Day read that its purpose was the rededication of the American people "to the ideals of equality and justice under law in their relations with each other as well as with other nations." Griffin Bell is pictured second from the left (above) next to Rev. Frank Harrington (left). Bell is also captured below (right), as he and Dr. Manning Pattillo assemble in front of the library. (Below, photograph by Ross Henderson Photography.)

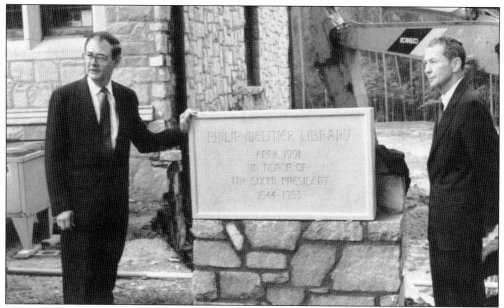

The Philip Weltner Library was named in honor of the 14th president of Oglethorpe University. Weltner served as chancellor of the university system in Georgia, and he was appointed to the state board of regents, a system he was instrumental in founding. Pictured above with the cornerstone are Philip Weltner's son, Charles (right), and Oglethorpe University president Donald S. Stanton (left). Charles, an Oglethorpe graduate and prominent Atlanta attorney, served as a U.S. congressman and associate justice of the Supreme Court in Georgia. The audience pictured below on September 11, 1990, hears the official announcement given by Paul Dillingham that Woodruff funds have been awarded for the library addition project. The addition was designed by Cherry Roberts, and ground breaking for the project was held January 24, 1991. The dedication for the completed structure took place on September 17, 1992.

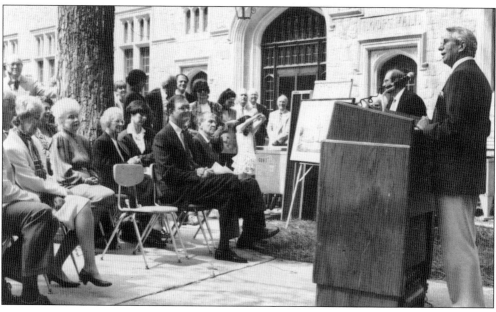

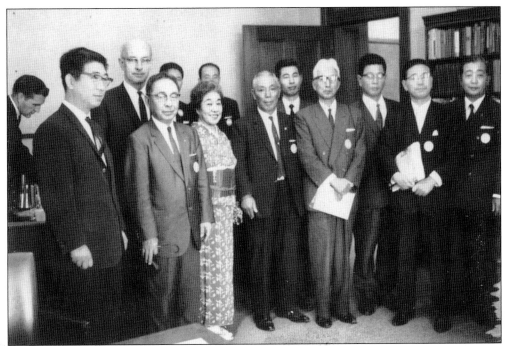

In 1990, Seigakuin Schools of Tokyo formed a cooperative program with Oglethorpe. In 1988, an institutional relationship had existed between Oglethorpe, Seigakuin University, and Joshi Seigakuin Junior College in Japan. The new agreement utilized the Jim Cherry School on the west edge of campus for the Seigakuin Atlanta International School. A mission school of the Disciples of Christ, this was the 10th school established for early childhood education.

Every Oglethorpe Day, a lone piper calls the campus to the Petrels of Fire race. Started on February 14, 1990, by track coach Bob Unger, the event re-creates the race at Cambridge University that was the inspiration for the film *Chariots of Fire*. Runners race around the quad in an attempt to complete the 270-yard course before the chimes ring out the noon hour.

BIBLIOGRAPHY

Hudson, Paul Stephen. "A Call for 'Bold Persistent Experimentation': FDR's Oglethorpe University Commencement Address, 1932." *The Georgia Historical Quarterly* 2 (Summer 1994): 361–375.

Tankersley, Allen P. *College Life at Old Oglethorpe*. Athens: University of Georgia Press, 1951.

Thomas, David N. *Oglethorpe University: A Sesquicentennial History 1835–1985*. Unpublished manuscript, 1986.

Subject and Personality Files, Oglethorpe Archives, Oglethorpe University